ILLUMINATING
WISDOM

iLLuminating wisdom

Words of wisdom, works of art

CALLIGRAPHY BY DEIRDRE HASSED

TEXT BY CRAIG HASSED

EXISLE
PUBLISHING

First published 2017

Exisle Publishing Pty Ltd
'Moonrising', Narone Creek Road, Wollombi, NSW 2325, Australia
P.O. Box 60–490, Titirangi, Auckland 0642, New Zealand
www.exislepublishing.com

A CiP record for this book is available from the National Library of Australia.

ISBN 978-1-925335-35-4

Designed by Mark Thacker, Big Cat Design
Typeset in Mrs Eaves 11 on 14pt
Printed in China

This book uses paper sourced under ISO 14001 guidelines from well-managed forests and
other controlled sources.

2 4 6 8 10 9 7 5 3 1

Dedicated to our parents,
Anne & Harry and Shirley & Bob,
and to our dear friends, Beverly & Tigger,
with love and gratitude.

Whatever a person offers to me,
whether it be a leaf, or a flower,
or fruit, or water, I accept it,
for it is offered with devotion
and purity of mind.

Bhagavad Gita IX:26

contents

Foreword

Wisdom is a beautiful thing, perhaps one of the most beautiful, and calligraphy is the art of beautiful writing. It is therefore not surprising that for many centuries, various cultures around the world have presented their traditional literary and spiritual wisdom in the beautiful art form of calligraphy. It is through the art that the reader's heart and mind may be drawn deeply and contemplatively to connect with the meaning of the words.

Illuminating Wisdom is a collection of spiritual and philosophical quotes drawn from many of the world's great wisdom and literary traditions, as well as from some more contemporary sources such as great statespersons and scientists. It is an art book with some text, rather than a textbook with some art. The quotes have been set to calligraphy by Deirdre Hassed, one of Australia's leading calligraphers, and

I have provided the accompanying text. Deirdre and I have long shared a love of philosophy, which is the love of wisdom, and so this collaboration is a natural expression of what we hold most dear.

This book can be enjoyed by simply browsing through the artwork or you might like to read about the quotes in more depth. Engaging with the quotes intellectually may help generate a deeper understanding but often it is when the intellectual mind stops thinking and gets out of the way, as it were, that real illumination occurs. As such, you may find it helpful to use the quotes in a more contemplative or meditative way. The accompanying text is there to provide some background on the writer and the philosophical tradition from which they come, as well as the meaning of the words themselves, although there is no one right meaning

or way to understand wisdom. The text is just a starting point.

We have been keen to draw on sources of wisdom from Eastern, Western, indigenous, ancient and contemporary sources. At various points some biographical or philosophical background is provided about the author or the tradition from which the quote comes. It has been somewhat heartbreaking to not be able to include so many other beautiful quotations and we apologize for that. Wisdom may be infinite but there is definitely a limit to the space in this book.

In reading the quotations, the similarities and recurring themes between them is striking. It is easy to point to differences and hair-splitting logic that attempts to divide people, religions and cultures, but what is far more persuasive is the commonality and unity conveyed through wisdom. From the perspective of wisdom, differences are superficial, but meaning is universal. Wisdom has no borders or limits as far as time and place are concerned. It is therefore hoped that *Illuminating Wisdom* celebrates what makes each individual wisdom tradition unique and beautiful in its own right, but over and above that, emphasizes the essential unity of wisdom by highlighting what they all have in common.

Themes for the quotes include love, beauty, truth, justice, service, compassion, virtue, unity, peace and wonder. We hope you get as much joy out of reading this book as we have had in producing it.

Craig and Deirdre Hassed

Illuminate

The first calligraphic work is **Illuminate** because the word 'illuminate' is such a fascinating one, with many different meanings of relevance to this book. To begin, many calligraphic masterpieces are illuminated with rich gold and silver gilding that brilliantly reflect light, giving lustre to the artwork. Equally, the still mind, like a clear and undistorted mirror, reflects pure awareness into the world and then truly reflects an undistorted view of the world back to the mind. When this happens we see things as they are. Light is shone in dark places and understanding and insight follow. From this arises illumination or wisdom.

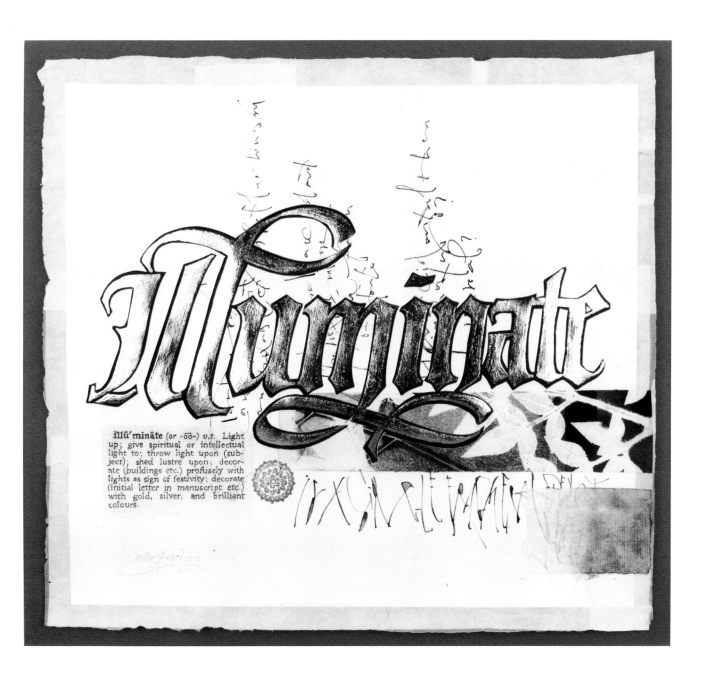

illŭ′mināte (or -ōō-) *v.t.* Light up; give spiritual or intellectual light to; throw light upon (subject); shed lustre upon; decorate (buildings etc.) profusely with lights as sign of festivity; decorate (initial letter in manuscript etc.) with gold, silver, and brilliant colours.

Religious Traditions

For millennia the collected wisdom of a society has been communicated through its religion. However, people vary in their natures. They are devotional but also have intellect or reason. While most people are disposed to their faith without much interest in questioning what has been taught, others are more disposed to reflection and inquiry. Therefore spiritual traditions very often have two main arms: one being for those disposed to faith — the religious — and another, more mystical or philosophical arm for those drawn to reflection. So, for example, you have the Christian religion and its smaller philosophical tradition of the Gnostics. In Islam you have the religion followed by the great majority of Muslims but there is also the more philosophically minded beliefs and practices of the Sufis. Because these traditions often see, describe and practise things differently they do not always see eye to eye. Unfortunately, the religious tradition, being far larger, has at various times persecuted those following the philosophical path.

It is not necessarily the case that one path is superior to the other, but just that one path may suit one kind of spiritual seeker more. Each path can have its traps and challenges. A person can put their faith in things that may not be true or do not stand up to scrutiny or reason, which has led to modern clashes between religion and science. Equally, a person who questions and inquires too much may never get beyond that to dive deeply into the immersive and direct experience that the person of simple devotion enjoys. They may constantly debate about the nature of the ocean without ever jumping in.

Religions are often divided according to whether they are non-theistic (don't believe in a God) like Buddhism, polytheistic (believe in many Gods) like the Hindu tradition, or monotheistic (believe in one God) like Judaism, Christianity or Islam.

Despite the fact that they can generate much debate and argument, differences in dogma and religious practices may be more cultural, historical and arbitrary than they are essential. But differences in whether God exists, how many Gods exist, or the nature of God, go a little deeper. However, perhaps even these differences are reconcilable and are more semantic than fundamental.

For example, what one religion calls pure, undifferentiated, unlimited consciousness or being, as in Buddhism, another may call God — 'God is light'. What one polytheistic religion calls many Gods, as in the Indian tradition, another monotheistic religion may call the many universal forces in nature. The philosophical arm of the Indian tradition is based on *Advaita* ('*a*' meaning 'not' and '*dvaita*' meaning 'two') meaning that there is only One and no second. Hence, according to what outwardly appears to be a polytheistic religion, there are many different expressions of the one universal being, and that universal being has many different names, making it seem polytheistic when at its philosophical heart it may not be. Furthermore, when one religion proclaims to be monotheistic — 'there is one God' — then there is much potential for division with people of other monotheistic religions because humans, being what we are, tend to project our individual identity on things and proclaim that our God is the only right one. If, however, the emphasis is slightly different, in that 'there is one God' means that 'God is one', then we are all together. Religion, after all, comes from a Latin word, *religare*, meaning 'to bind together', not to divide.

These are weightier questions than we have space for here so let us dive into a few quotes from some of the world's religious traditions.

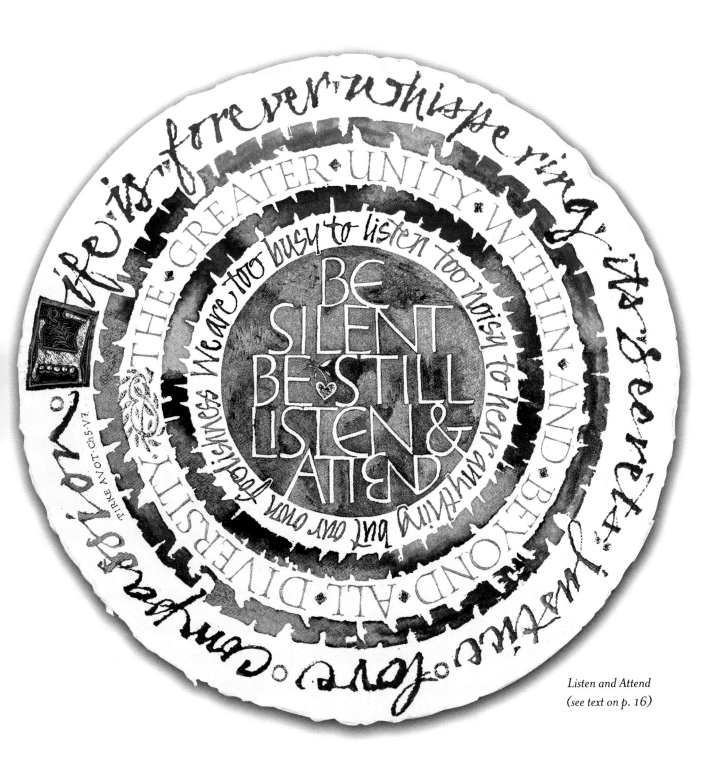

life is forever whispering its secret justice love compassion

THE · GREATER · UNITY · WITHIN · AND · BEYOND · ALL · DIVERSITY

We are too busy to listen too noisy to hear anything but our own foolishness

BE
SILENT
BE·STILL
LISTEN &
ATTEND

PIRKE AVOT · Ch 5 · V7

Listen and Attend
(see text on p. 16)

Judaic Tradition

The Judaic tradition goes back over 3000 years and from it have arisen other great religions like Christianity and Islam. Although relatively small in terms of the number of adherents, the influence of the Jewish culture and religion has been enormous.

The teachings of Judaism are vast, as are the number of sects, each with their slightly different emphasis, rules and doctrines. There are the core religious texts like the Torah, Jewish Bible, Talmud and Kabala, and then there are the ethical precepts found in lesser-known and smaller texts such as the *Pirkei Avot*, which translates to the 'Chapters of the Fathers'.

Two quotes have been chosen from this text because they echo two key messages that go to the heart of all great wisdom traditions: the importance of awareness and the pre-eminence of the eternal present.

The world is suffering enormously under the tyranny of escalating levels of distractedness, depression, suicide, addiction, conflict and self-inflicted lifestyle-related illnesses. Conventional approaches have been unable to effectively deal with these issues, perhaps because they are based on conventional assumptions that do not get to the underlying causes. Such problems seem to flourish in times when materialism reigns, happiness is interpreted as hedonism, oneness is interpreted as individuality, and an increasing number of people have little or no meaning in life. It is like we are living in a kind of new 'dark age'. Against this backdrop it is not surprising that the world is seeking insights from wisdom and rediscovering its meditative roots aimed at increasing awareness. It is like we are collectively trying to turn on the light switch, light being a metaphor for increasing awareness.

In many ways *Listen and Attend* (p.15) strikes a cord with the modern investigation into mindfulness. Although mindfulness is often seen as a Buddhist practice, the principles of mindfulness are really universal and can be found across all wisdom traditions. Whenever or wherever we wake up we are mindful.

In this distracted and fast-paced world we need to stop, be silent and pay attention. When we do this we are, or at least the mind is, in the present moment.

Although a material and relativist view of the universe sees transience and change as the only constant, a spiritual and transcendent experience of the present moment confounds every assumption we generally make about life and existence. We, for example, think of eternity as a really, really, really long time, whereas wisdom sees it as no time at all. The only moment that really exists or that has any legitimate claim on reality is the present moment. It is eternally present, now.

The past has gone and only exists as an echo of things already passed, and the future is only an imagination of things to come.

Neither exists except in the mind. Therefore, as intimated in *The Eternal Now* (p.18), the present moment is reality; it is now.

The Christian tradition and the Bible

The Christian tradition grew and took its spiritual foundations from the Judaic tradition but was then inspired by the teachings of Jesus Christ. From its humble beginnings, Christianity 'conquered' and spread throughout the Roman Empire which, because of the eventual spread of European culture, exploration and military might, was the perfect

vehicle for it to subsequently become the largest single religion in the world.

The *Book of Wisdom* (p.19), or the Wisdom of Solomon (7:7–11), is an apocryphal book from the Old Testament of the Bible. As with Pallas of the Greek tradition, wisdom is personified as a beautiful woman. The coming of wisdom is dependent on the condition that we are prepared to leave everything else of lesser value and to cherish wisdom above all. We have to leave or must lose our attachments to possessions, positions, the body, pleasure and even to our closely cherished opinions. We have to leave all of this to be open for wisdom to enter into the heart and mind, for the heart and mind that are preoccupied with things that pass will never be able to attain that which doesn't pass. Something that is true today and false tomorrow might be worldly knowledge, but it is not true wisdom, for wisdom is eternal and is about that which does not pass.

A mind that has been purified and become quiescent and peaceful is like a smooth lake that reflects consciousness truly and without distortion.

It is radiant and illuminates things as they are. This is likely to be the symbolism of the halo of light around the head of the wise and holy, which is seen in the art of so many spiritual traditions.

The Psalms from the Old Testament were important in the Judaic tradition and are often attributed to King David, although that is hard to

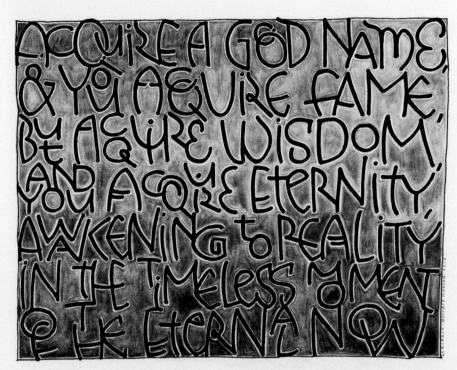

The Eternal Now (see text on p. 17)

Opposite: The Book of Wisdom (see text on p. 17)

I PRAYED, AND UNDERSTANDING WAS
GIVEN ME; I ENTREATED, AND THE SPIRIT
OF WISDOM CAME TO ME. I ESTEEMED
HER MORE THAN SCEPTRES AND THRONES;
COMPARED WITH HER, I HELD RICHES AS
NOTHING. I RECKONED NO PRICELESS STONE
TO BE HER PEER, FOR COMPARED WITH HER,
ALL GOLD IS A PINCH OF SAND, AND BESIDE
HER, SILVER RANKS AS MUD. I LOVED HER
MORE THAN HEALTH OR BEAUTY, PREFERRED
HER TO THE LIGHT, SINCE HER RADIANCE
NEVER SLEEPS. **IN HER COMPANY**
ALL GOOD THINGS CAME TO
ME, AT HER HANDS RICHES
NOT TO BE NUMBERED.

From the Book of Wisdom, Chapter 7 · Verses 7-11

DOMINE

Dominator noster
quam grande est nomen tu
um in universa terra qui
posuisti gloriam tuam sup
er caelos et ore infantium
et lactantium perfecisti lau
dem propter adversarios
meos ut quiescat inimicus
et ultor videbo enim cael
os tuos opera digitorum tu
orum lunam et stellas qu
ae fundasti quid est hom
o quoniam recordaris eius
vel filius hominis quoniam
visitas eum minues eum
paulo minus a Deo gloria
et decore coronabis eum
dabis ei potestatum super
opera manuum tuarum
cuncta posuisti sub pedibus
eius oves et armenta omni
a insuper et animalia agri
aves caeli et pisces maris
qui pertransent semitas
ponti Domine Dominat
or noster quam grande est
nomen tuum in universa
terra LIBER PSALMORUM

scripsit DEIRDRE HASSED M.M.IX

O LORD, OUR
LORD, how excellent
is thy name in the earth

WHO HAST SET thy GLORY
ABOVE THE HEAVENS,

2 Out of the mouth of babes
and suckings hast thou
ordained strength because
of thine enemies, that thou
mightest still the enemy
and the avenger.

3 When I consider thy heavens,
the work of thy fingers,
the moon, and the stars,
which thou hast ordained;

4 What is man that thou art
mindful of him? and the son
of man, that thou visitest him?

5 For thou hast made him
a little lower than the angels,
and hast crowned him
with glory and honour.

6 Thou madest him to have
dominion over the works
of thy hands; thou hast put
all things under his feet;

7 All sheep and oxen, yea,
and the beasts of the field;

8 The fowl of the air, & the fish
of the sea, and whatsoever
passeth through the
paths of the seas.

O LORD, OUR LORD, HOW
EXCELLENT IS THY NAME
IN ALL THE EARTH!

Love your enemies,
bless them that curse you,
do good to them that
hate you, and pray for
them which despitefully
use you & persecute you;
that ye may be the children
of your Father which is
in heaven: for He maketh
his sun to rise on the evil
and on the good, & sendeth
rain on the just and on
the unjust. MATTHEW Chapter 5: 44-45

Opposite: Psalm 8
(see text on p. 22)

Love Your Enemies
(see text on p. 22)

fully verify. The Psalms are poetic and are meant to be songs of praise accompanied by instrumental music. An interesting anecdote is that many of the translators of the King James Bible, which is the first English translation, were friends with William Shakespeare and he himself may have even worked on the project, giving the translation some of its poetic beauty. In the 46th Psalm the 46th word from the beginning is 'shake' and the 46th word from the end is 'spear' and this is thought to be a tribute to Shakespeare for his 46th birthday in 1611, when the translation was completed.

One thing that makes the reading of the scriptures sometimes difficult to understand for followers of a faith, and easy to dismiss for non-followers, is that spiritual teachings are so often cloaked in metaphor and allegory. Taken literally, they can be difficult to interpret, hard to accept or be out of step with scientific or historical 'facts'. Taken too loosely, they can be interpreted in any way that suits an individual's or group's particular biases.

Psalm 8 (p.20) begins as a song in praise of God and goes on in the well-known phrase to describe humanity as being 'a little lower than the angels' and yet having dominion over the natural world. It is as if humanity has a dual nature straddling what is both divine and worldly. Humans have the opportunity for transcendence and at the same time have stewardship over other creatures and the environment. Equally, we can ascend to the highest level but we can also become consumed by the material world. This is indeed a privileged position that comes with

responsibility, a responsibility that humanity hasn't always met wisely in recent times, considering the increasingly materialistic values common in society today and how we have damaged the environment since the industrial era.

The New Testament is, of course, centred on the teachings of Jesus Christ. In contrast to the sternness and retribution that were common in some sections of the Old Testament, Jesus preached a radical form of forgiveness and tolerance, even to one's enemies. Such a view is not isolated to Jesus. Socrates expressed a similar view. More contemporary examples would include Victor Frankl, the Dalai Lama and Nelson Mandela, who repeatedly called for forgiveness, patience and compassion in the face of persecution. What makes Jesus's words even more remarkable, however, is the brutality of the persecution that he endured through the crucifixion and yet he maintained this attitude right to the end.

Loving those who hate, persecute or use us goes counter to just about every prompting we would see as natural in such a situation.

Love Your Enemies (Matthew 5:44–45; p.21) is a famous distillation of this ethos of infinite compassion, patience and forgiveness. For such a sentiment to not merely be spoken, but to be deeply felt and lived, is extraordinary. Quite possibly there are two things we require for that to be a viable proposition. First is a deep connection with

our inner essence, which rises above the pleasures and pains, ups and downs of worldly life, so that the physical harm or loss of some object is a small thing by comparison. If we are more than the body then we are not harmed when our physical body is harmed nor diminished when we are deprived of our possessions.

Second, if our understanding is deep enough then we may appreciate that when someone acts unjustly then they are just harming or deforming their own soul. We can observe this by being mindful of the effect on our own emotional and mental state when we act in a cruel or maleficent way. The material gain from an unjust action is superficial, but the harm is deeper and more essential. The remedy, and the path to a heart and soul at rest, is to act with integrity and compassion, even in the face of injustice.

Let Your Light Shine (p.24), from Matthew 5:16, is an exhortation to manifest all that is good within us through our words and actions. When someone acts in such a way, they not only do credit to themselves, they do credit to that which is essential and divine within themselves, i.e. God or the father to their soul. In this way the individual soul connects with the universal soul, the same self or soul within us all.

From this perspective, treating your neighbour as yourself is not an aspiration so much as a statement of fact.

Our neighbour is oneself every bit as much as every cell of our body is a part of the whole.

Let Not Your Heart be Troubled (p.26) from the Gospel of John 14:27 is a simple and short statement of consolation. The full quote speaks about the solace that comes from having faith in the teachings of Christ as the ultimate source of wisdom, comfort and guidance. When a person remembers a quote they may not often recite the whole text but simply distil the essence of it as a kind of succinct affirmation. In this short quote we are reminded simply to remember to rest in the peace that comes with the truth, for the truth itself offers complete peace and, ultimately, there is no rest from our travails and worries without it.

The Christian tradition from non-biblical sources

An early German devotional was the Benedictine abbess, Hildegard of Bingen (1098–1179). She was unusual for her day in that she was not only head of a religious community but also a multitalented philosopher, mystic, author, composer, healer and natural scientist. She was all the more remarkable because she was also so outspoken, an unusual trait for women of that time. This outspokenness not only won her many admirers, including the Pope, but also many detractors from the more conservative clergy of the day. The interest in Hildegard has gone through

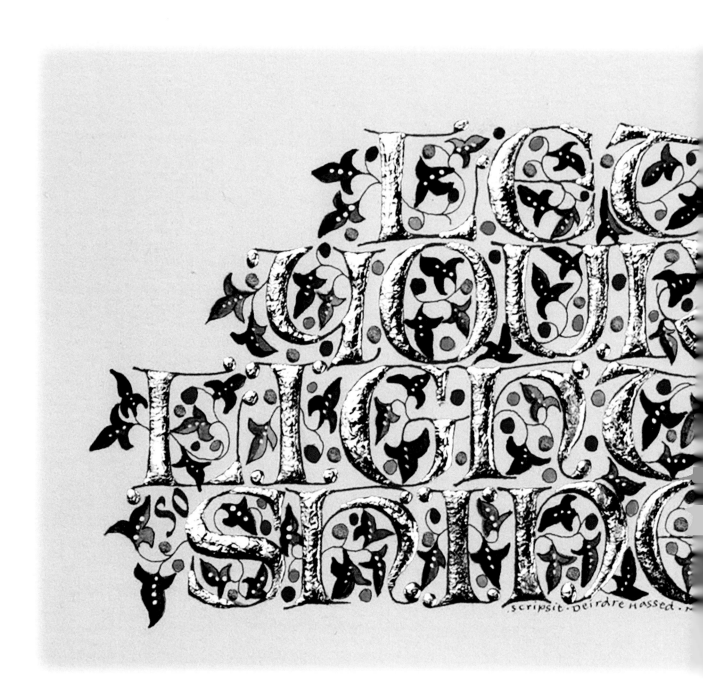

.scripsit.Deirdre.Hassed.

before men,
that they may see
your good works,
and glorify
your Father &
which is
in heaven

ST·MATTHEW·Ch5·V16

Let Your Light Shine (see text on p. 23)

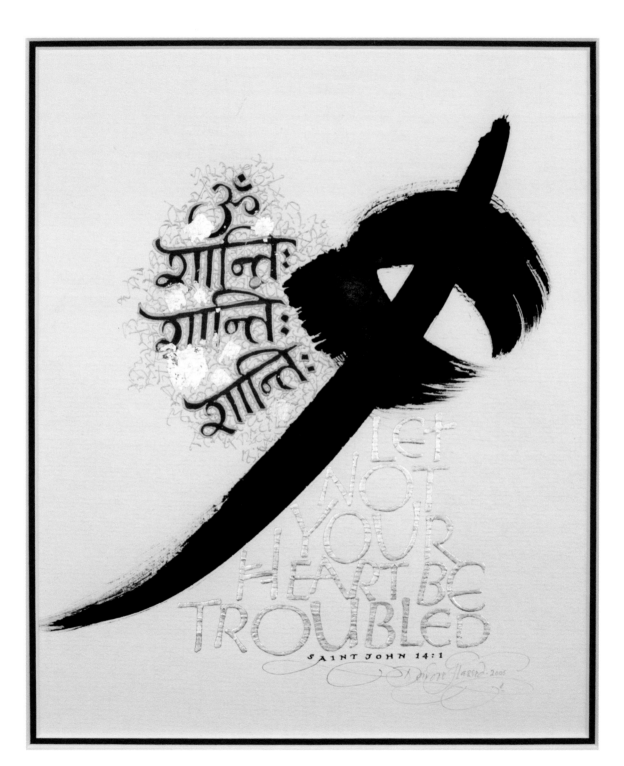

ॐ शान्ति: शान्ति: शान्ति:

LET NOT YOUR HEART BE TROUBLED

SAINT JOHN 14:1

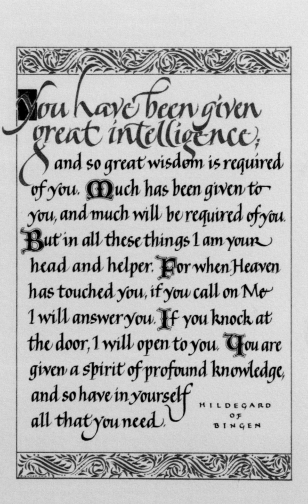

You have been given great intelligence; and so great wisdom is required of you. Much has been given to you, and much will be required of you. But in all these things I am your head and helper. For when Heaven has touched you, if you call on Me I will answer you. If you knock at the door, I will open to you. You are given a spirit of profound knowledge, and so have in yourself all that you need.

HILDEGARD OF BINGEN

Opposite: Let Not Your Heart Be Troubled (see text on p. 23)

Great Wisdom is Required of You (see text on p. 30)

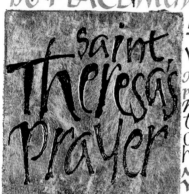

May today there
be PEACE within

saint
Theresa's
Prayer

MAY YOU TRUST GOD
THAT YOU ARE EXACTLY
WHERE YOU ARE MEANT TO BE,
May you not forget the infinite
possibilities that are born of faith.
may you use those gifts
that you have received
and pass on the love that
has been given to you.
MAY YOU BE CONTENT KNOWING
YOU ARE A CHILD OF GOD.

Let this presence settle into your bones, and allow
your soul the freedom to sing, dance, praise & love.
It is there for each and every one of us.

St Theresa's Prayer (see text on p. 31)

Opposite: Let Me Sing the Song of Love (see text on p. 30)

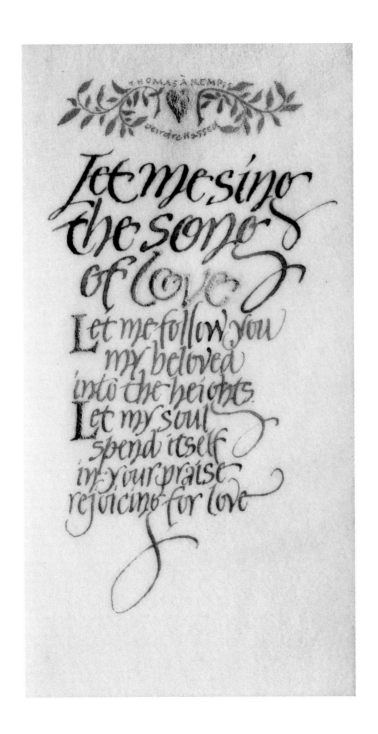

Let me sing
the song
of love

Let me follow you
my beloved
into the heights.
Let my soul
spend itself
in your praise
rejoicing for love

something of a revival in recent years, largely through the popularity of her writings and ethereal music. The piece, *Great Wisdom is Required of You* (p.27), speaks to the reader with the voice of the Divine. It exhorts us to not only acknowledge the intelligence that we have been given but also the responsibility to use it with wisdom.

Help comes from Heaven if we ask, but it speaks to us from within.

We need an open heart to unlock it. The idea that spiritual insight speaks to and through us from within is a radical departure from a doctrine emphasizing the pre-eminence of the church as the vehicle for truth, rather than direct revelation to the individual.

One of the most loved saints of the Christian tradition is St Francis of Assisi (1181–1226). He was born as Pietro di Bernardone into a wealthy merchant family in Assisi, Italy. 'Francis' soon became his nickname as he loved all things French. He led a high-spirited life and also fought in a number of military campaigns. After illness and reflecting on his worldly experiences, Francis had a spiritual conversion. He renounced his wealth and took to begging and preaching in the streets.

Through his sincerity and devotion Francis attracted increasing numbers of followers, to such an extent that Pope Innocent III authorized a religious order under his name in 1210.

This became the Franciscans. Francis cared little for possessions, including his body, and had worsening health over the years. He was also noted for loving nature and animals and received the stigmata during a religious ecstasy in 1224. The famous *St Francis' Prayer* (p.33) is both a prayer of total surrender and a yearning for his heart, body and mind to be an instrument of truth and service. As it has ever been, in his day there was much suffering in the form of hatred, injury, error, doubt, despair, darkness and sadness. As the Buddhist tradition reveres effective action guided by infinite compassion to relieve suffering in the world, so too does St Francis want his life and example to be totally devoted to uplifting and comforting others and relieving their suffering. He did just that and is revered for his humility and living his teaching, not just preaching it. Francis was canonized by Pope Gregory IX in 1228 and, along with St Catherine of Siena, he became patron saint of Italy.

Thomas a Kempis (1380–1471) was a Dutch mystic and a Canon of the Church. He is best known as the author of the famous and much loved devotional book, *The Imitation of Christ*. His prayers are deeply devotional. When he speaks of the beloved in *Let me Sing the Song of Love* (p.29) it could easily be interpreted that he is speaking of some worldly love but he is, of course, speaking of God. The truly devotional heart seeks unity with the beloved through love. The lover wants to imitate and serve the beloved in every way, in total surrender, such that any barrier between them is removed. Hence, true love is not of things or people that pass, but of the eternal that does not pass.

St Teresa of Avila (1515–1582) was a Catholic nun of the Carmelite Order. She was Spanish and is considered to be a mystic, contemplative and writer. She is also well known for reforming the Carmelites and joining forces with St John of the Cross during the Counter-Reformation, which was a resurgence of the Catholic Church begun in the 16th century in response to the Protestant Reformation.

Following a spiritual path requires significant mental discipline.

Much of it is directed to the mind giving up old and unhelpful habits and cultivating new and useful ones. In this saying, *I Shape My Heart Like Theirs* (p.32), St Teresa is speaking about a habit she practised through prayer in order to cultivate greater compassion. It was not just a matter of bringing to mind all those she had met that day, but to purposefully put herself in their shoes, to look at the world from their perspective, to cultivate a heart full of compassion, and to see those with whom she walked as if she and they were one.

St Thérèse of Lisieux (1873–1897), also known as 'The Little Flower', led a short but extraordinary life. Born in France, she entered the Carmelite Order in Lisieux, Normandy, at the age of 15. Thérèse led a quiet and anonymous life of humility, simplicity, purity and piety but after her death she because far more widely known because of her writings, in particular the autobiographical *The Story of a Soul*. Since her untimely death in 1897 due to tuberculosis,

Thérèse has been given many honours, which would probably have overwhelmed someone of her humility. She was beatified in 1923, canonized in 1925, declared co-patron of the missions with Francis Xavier in 1927, named co-patron of France in 1944, and Pope John Paul II declared her the thirty-third Doctor of the Catholic Church in 1997. Of her many writings possibly the most famous is *St Theresa's Prayer* (p.28). The prayer is solemn but it is in no way dour or austere.

It exhorts us to find peace within, and through that peace to trust and open ourselves to the divine and infinite possibilities that await one who is awake to them.

From that arises an expression of joy through song, dance, praise and love.

John Tillotson (1630–1694) was the Archbishop of Canterbury from 1691–1694 and was married to a niece of Oliver Cromwell. He was noted for his preaching in a simple, approachable and direct style, which greatly appealed to the public. *To Be Happy* (p.34) points to the importance of a mind at rest, free of entanglement with the trials and tribulations of daily, physical existence.

Everything in worldly life can be endured with a healthy and tranquil mind, and virtually nothing can be endured without it.

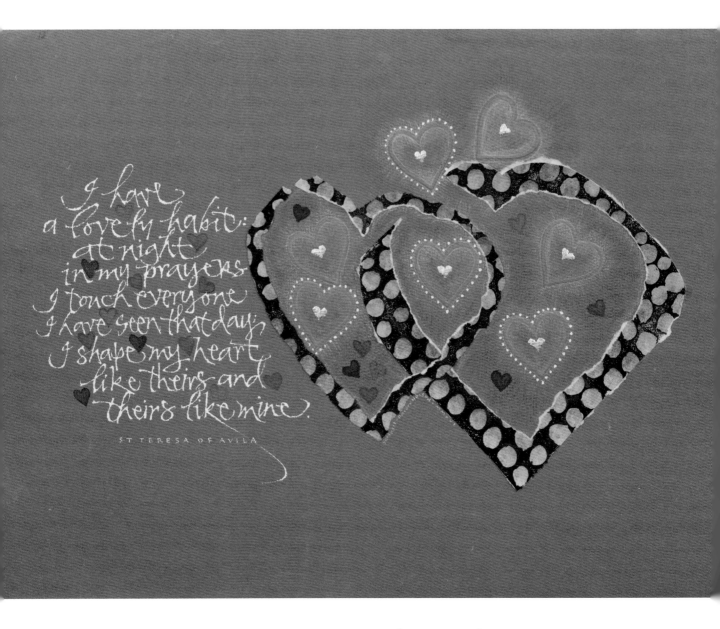

I have
a lovely habit:
at night
in my prayers
I touch every one
I have seen that day,
I shape my heart
like theirs and
theirs like mine.

ST TERESA OF AVILA

I Shape My Heart Like Theirs (see text on p. 31)

LORD, MAKE ME AN INSTRUMENT OF THY PEACE:

Where there is hatred, let me sow love;
Where there is injury, pardon;
Where there is error, truth;
Where there is doubt, faith;
Where there is despair, hope;
Where there is darkness, light;
And where there is sadness, joy.

ST FRANCIS OF ASSISI

O Divine Master,
Grant that I may not so much seek
To be consoled as to console;
To be understood as to understand;
To be loved as to love.
For it is in giving that we receive;
It is in pardoning that we are pardoned;
And it is in dying that we are born
to eternal life.

St Francis' Prayer (see text on p. 30)

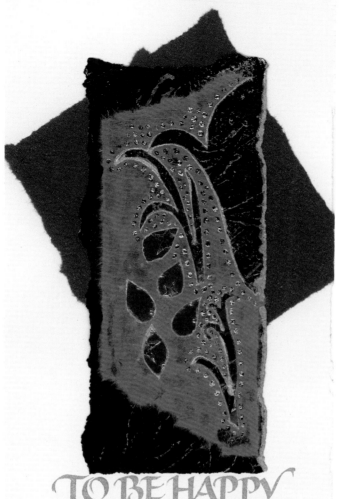

TO BE HAPPY
is not to be freed from
the pains & diseases
of the body, but from
the anxiety & vexation
of spirit; not only to
enjoy the pleasures
of sense, but peace of
conscience & tranquility
of mind.

TILLOTSON

To Be Happy
(see text on p. 31)

If you wish
to be like a
little child,
study what
a little child
could under-
stand ~nature~

And do what a little child
could do ~ L O V E.

CHARLES KINGSLEY

Be Like a Little Child (*see text on p. 37*)

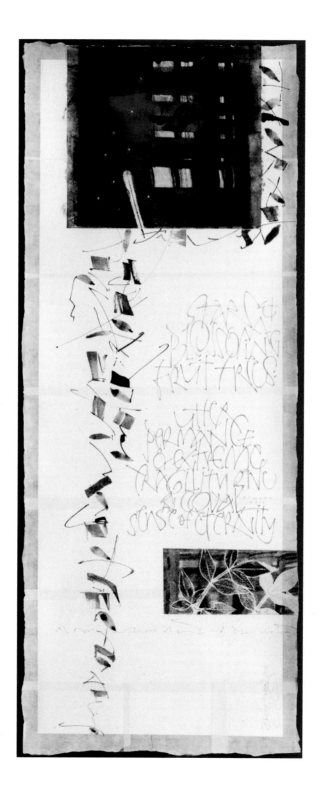

Stars and Blossoming
Fruit Trees

Nature is often a source of inspiration for literature and also for spiritual experiences. In nature we can tap into a life force that extends well beyond our insignificant status as an individual. Charles Kingsley (1819–1875) was a priest but also a Cambridge professor and founded the Chester Society for Natural Science. He was also a good friend of Charles Darwin and supported him in his work, which was no doubt unusual for a cleric of the day. The quote, **Be Like a Little Child** (p.35), hints at his love of nature and also at the innocence, simplicity and openness that is characteristic of a child.

> **It is indeed wonderful to see a child gazing in joy and amazement at the natural environment, before their eyes are dimmed by the cares of the world.**

That sense of awe and wonder is a spiritual experience in itself. Rare is the person who maintains that wonder beyond their early childhood. One such person was Einstein, who wrote, 'We never cease to stand like curious children before the great mystery into which we are born.'

Simone Weil (1909–1943) from France was an interesting and unusual person in many respects. She was originally a teacher but became a left-leaning political activist. Later she became a member of the French Resistance under Charles de Gaulle, upon whom she had a considerable influence. What was particularly uncommon was that such a person should also be a Christian mystic. Weil wrote extensively but her works and notebooks became far more widely read after her death and have subsequently been translated into many languages.

In *Stars and Blossoming Fruit Trees* (opposite) Weil hints at the curious paradox of finding the eternal in the transient. The quiet, permanent and unmoving sentinel nature of stars is contrasted with the extreme fragility and impermanence of the blossoms on a fruit tree. This paradox is written of in wisdom traditions and by many a spiritually-minded author. T.S. Eliot wrote of the 'still point of the turning world', indicating the still, conscious, central being that finds itself amidst the activity of worldly life. If we are not connected to that still centre, life becomes somewhat meaningless, confusing and agitating. Then there is Plato's *Symposium* where, through the character of Diotima, he writes, 'to the mortal creature, generation is a sort of eternity and immortality'. In generation, birth and death the mortal creature experiences a kind of immortality because it lives beyond its own brief lifetime.

> **The cycle from seed to tree, blossom, fruit and back to seed is a perfect metaphor for this eternal cycle. Even the birth and death of the universe seems to run parallel to or reflect this eternal cycle.**

The aim is not to identify ourselves with that which is fragile and passing, but with that which is stable and unchanging in us, the consciousness that is behind it all.

Gnosticism

'Gnosis' is an ancient Greek word meaning 'knowledge'. In keeping with spiritual paths based on philosophy rather than faith, the Gnostics sought enlightenment which is to know, rather than to merely believe. As a philosophical movement it is likely the Gnostics predated Christianity and many trace their roots to the Greek Platonic tradition, as well as the Egyptian tradition through Hermes and the Zoroastrians. As with many other spiritual and philosophical paths, having a direct experience of God, being one with God, the search for liberation, and transcending the world were some of their basic tenets. Being closely associated with Christianity brought them into conflict with the Christian religious orthodoxy of the day. Many Gnostics lived a monastic life in the desert but at various times many of these communities were persecuted and nearly wiped out.

There has been a significant revival of interest in the Gnostic teachings since the discovery of a major corpus, or set of texts, called the Nag Hammadi library. Amazingly these texts written on papyrus (a kind of paper commonly used in Egypt and made from the papyrus reed) were discovered by a farmer in 1945, buried near the mouth of a cave in the desert near Nag Hammadi in Upper Egypt. Along with the Gnostic texts were some other writings including the *Corpus Hermeticum* of Hermes Trismegistus and sections of Plato's *Republic*. Tragically, a significant number of the codices (or ancient books) were burned by the farmer before their significance was discovered. What was left of these texts is still being translated but the first and most famous book arising from this work has been Elaine Pagel's *The Gnostic Gospels*.

The Gnostic quote **That Which is Within You** (p.40) is from *The Gnostic Gospels*. Like many mystical philosophical writings it is full of paradoxes that don't seem to make sense. How can something within you be your friend and salvation and at the same time be your enemy and destruction? It doesn't make sense unless one has direct experience to illuminate and resolve the apparent contradiction. The Gnostics, along with many other wisdom traditions, speak about there being two apparent selves — one that is pure, unalloyed and unchanging and another that is impure, alloyed and constantly changing. The former equates with pure consciousness and is the core of our being and the origin of all things good. The latter equates with ego and, arising from a mind trapped and limited by attachments and delusions, is the origin of all ignorance. If we know ourselves as the pure consciousness within and manifest that in our lives, then it will be our salvation. If, however, we believe ourselves to be the ego and manifest that in our lives then it will be our destruction. Mistaking our spiritual essence (what we really are) with the ego in the mind (what we seem or want to be) is a case of mistaken identity. Identifying with what we are not — the contents of the mind — and forgetting what we are, can lead to all manner of confusion and conflict within ourselves and with the outside world.

Islam

Islam is the world's second largest religion. Like Judaism and Christianity before it, it is a monotheistic religion tracing its roots to Abraham. The Muslim equivalent of the Bible is the Koran (Qur'an) which is taken to be infallible and the direct word of God or Allāh. In it the teachings and living example of the prophet Mohammed (570–632) are pre-eminent. He is generally considered to be the last in a line of prophets descending from Adam, Noah, Abraham, Moses and Jesus.

Islam is a highly devotional religion and the followers of Islam believe that the purpose of worldly existence is to worship God. Religious concepts and practices include the five pillars of Islam, obligatory acts of worship and following Islamic law, which covers virtually every aspect of life.

From its beginnings in the early 7th century in Mecca, Islam spread far and wide throughout the Arabian peninsula and from there all around the world. It experienced a golden age from the 8th to the 13th centuries, where it made an enormous contribution to society scientifically, economically, artistically and architecturally. This great legacy lives today.

Sufi comes from an Arabic word for 'perfect'.

The Sufis are the philosophical, mystical expression of Islam and are often associated with the 'whirling dervishes', whirling being a kind of meditative dance leading them into the exalted state of being one with God. They are best known for their poetry and also have some parallels with the Christian Gnostics in terms of the pursuit of the direct knowledge of and unity with God. Their poems and writings are often in the form of love poems and can be read as sensual and intimate exchanges between a man and his beloved. The deeper meaning, of course, is that the object of love is God. The Sufis worship Mohammad as the perfect man who lived the perfect godly life. A Sufi's life is often seen as being quite ascetic as they sought to free themselves from worldliness.

Rabia of Basra (717–801) was a female Muslim saint and Sufi mystic. She was born to a poor family but her father was very devotional. It is written that Muhammad appeared to him one night and prophesied that Rabia would become a great saint and lead many to the spiritual path. The family enjoyed a period of fortune and found favour with the Amir of Basra for a time, but after the death of her father, a caravan Rabia was travelling with was set upon by robbers and she was sold into slavery. Despite this, Rabia maintained great devotion and love of God, which was recognized by her master and he freed her to follow her worship. Rabia decided to go into the desert as an ascetic. Her devotion became legendary and her poems and prayers famous. It is said that she was a great source of inspiration for Rumi and other Sufi poets.

It Works (p.41) communicates the strong love and

If you bring forth
that which is within
you, then that which
is within you will
be your salvation.

If you do not bring
forth that which is
within you, then that
which is within you
will destroy you.

From·THE GNOSTIC GOSPELS

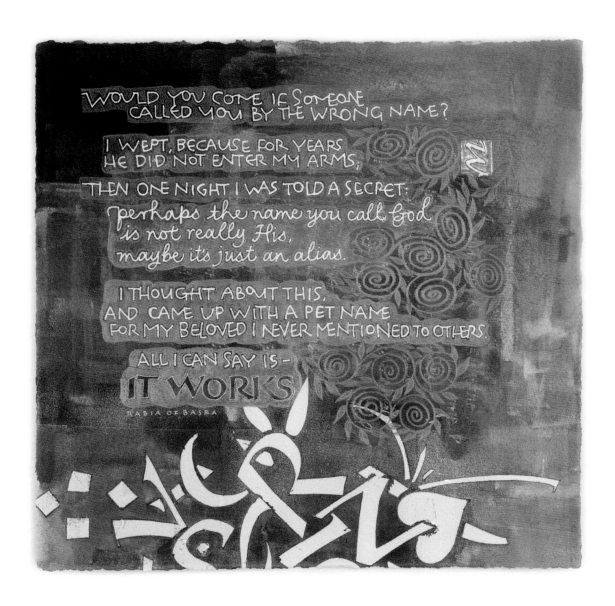

WOULD YOU COME IF SOMEONE
CALLED YOU BY THE WRONG NAME?

I WEPT, BECAUSE FOR YEARS
HE DID NOT ENTER MY ARMS;

THEN ONE NIGHT I WAS TOLD A SECRET:
perhaps the name you call God
is not really His,
maybe it's just an alias.

I THOUGHT ABOUT THIS,
AND CAME UP WITH A PET NAME
FOR MY BELOVED I NEVER MENTIONED TO OTHERS.

ALL I CAN SAY IS—
IT WORKS

RABIA OF BASRA

It Works (see text on p. 39)

Opposite: That Which is Within You (see text on p. 38)

devotion we associate with the Sufis where God is personified as the beloved. The longing of the lover for union with the beloved consumes the devotee day and night. The devotee does not feel whole without union with the beloved. Romantic love, which is the subject for so many love poems, movies and songs in contemporary life, is merely a shadow of this universal love for God represented in Rabia's poems. To the Sufi, we think we long for the person that is the object of our love, but ultimately that earthly love is a reflection of the longing for God.

Jalāl ad-Dīn Muhammad Rūmī, otherwise known as Rumi (1207–1273), is possibly the most famous and widely read of the Sufi poets. Today there is something of a revival of interest in his works. He was Persian, born in Afghanistan, and was indeed a multitalented man being a poet, jurist, Islamic scholar, theologian and mystic. He was very interested in the potential for music and dance to be used in spiritual practice and worship, and is thought to be instrumental in inspiring the whirling dervishes.

Central to Rumi's philosophy was that love is the drawing power to reunite the individual soul with the divine.

The impediment preventing unity is the mind. So it is through worship of God and purification of the mind that the barriers may be broken down and unity experienced.

The short passage in *Let Yourself Be Silently Drawn* (p.45) commends us to be drawn by what we love.

Many might interpret that to mean being drawn by our compulsions, attachments or addictions, but it is likely that love is being used in a different sense by Rumi. Compulsions, attachments and addictions inevitably lead us astray.

However, being strangely drawn by a love that will not lead us astray suggests something deep and intuitive, something more akin to a quiet calling than a compulsion.

Often we don't acknowledge our real passions for which we have a natural enthusiasm. We don't follow our calling in life. We get distracted. We are too noisy to stop for long enough to connect with what is within us. Life goes on tangents, or we rationalize following worldly things that appear to be better than our deeper calling but never are. We ignore our intuition, even to the point that our mind and heart scream out in protest, and even then we don't listen. To really listen we need to be still and silent. Socrates followed his heart in his pursuit of the truth and spoke of a divine voice that guided his life and never led him astray. It is likely that he and Rumi would have understood each other well.

Gratitude is a topic attracting a lot of interest these days, particularly in positive psychology circles. The modern world seems to be very adept at complaining and looking at events from a negative state of mind, to the point that it is easy to feel that we have little to be thankful for even if we live in

a blessed and comfortable situation. Wellbeing is much more a state of mind than a condition of our circumstances. Rumi's *Hear Blessings* (p.46) is a simple but beautifully poetic commendation to be open to the grace and good fortune surrounding us. Wellbeing is there if we care to see and acknowledge it. Again, the paradox is striking. Hearing a blossom falling makes no sense to anything other than a quiet mind that listens with the heart more than the ears.

Pearls are one of the quintessential symbols of riches referred to in many philosophical writings, and to the Sufis like Rumi there was nothing more valuable than wisdom. For example, 'the pearl of great price' should be bought with all we have because it is worth far more. *To Find a Pearl* (p.47) one has to dive deep into the ocean of existence. It, like wisdom, tends to be hidden, encased as it were in a shell which obscures it from view. It won't be found in the easy places, just as wisdom won't be found in the superficialities of life. We have to continually thirst for it and be prepared to give up preoccupation with worldly things to attain it. Ultimately, what we really value will reveal itself by what we follow.

The last of the Rumi quotes again confounds our usual ways of thinking. When we believe ourselves to be separated from something or someone we start to look for the missing object outside ourselves. That might be all very well if we are looking for a physical object, but true love is about complete unity and not something physical. True love is love of what is true in the person, not what is most superficial about them.

Like truth itself, true love transcends time, place and person.

We cannot find this outside ourselves, although we often assume we have to. Like a metaphorical blind person, we look but don't see or find what we are looking for. If we are lucky we stop and look within ourselves. *When Two Lovers Meet* (p.48) they realize that they were one all along. If that is so, then how could they ever be separated?

Khwāja Shams-ud-Dīn Muḥammad Ḥāfez-e Shīrāzī, otherwise known as Hafez (estimated 1320–1390), was another Persian poet. He too wrote extensively about love as the transforming power in the human soul, but is also well known for writing about hypocrisy, especially in religious circles. His poems and other writings are commonly used as prayers and sayings, especially in Iran, even to this day. Like the work of other Sufi poets, some western scholars merely read Hafez's writings as love poems between man and woman. They can be read that way but they should be read as the expression of a soul yearning for unity with the divine.

An Awake Heart (p.50) pours light just like a sky. This metaphor, used by Hafez, could be taken in many different ways. One way is to consider that the sun is symbolic of God, the truth, pure being or consciousness itself. The cloudy sky bathes us in a dim light at least, but the sky at night is dark and the world seems full of dim and foreboding shadows.

The heart that is open, or the conscience that has sincerely atoned for its wrongdoings, allows the sun's rays to illuminate, enliven and warm the world.

That is an awake heart. It possibly gives a much deeper sense of what it means to be truly mindful and aware.

Omar Khayam (1048–1131) was a Persian mathematician, astronomer, philosopher and poet, and a significantly influential scientist in the Middle Ages. He was born in Iran and travelled extensively throughout the Middle East. While he wrote and taught widely, he is best known for his quatrains or poems of four lines each, which were translated by Edward FitzGerald in the 19th century as the *Rubaiyat of Omar Khayam*. Like other Sufi poets, his poems are romantic but also metaphysical. They teach his philosophy through rich metaphors.

It is often said that mindfulness and being in the present moment is a Buddhist thing, when it is in fact a universal thing. There is much written about the importance of being in the present moment by the Sufis. In *Be Happy for This Moment* (p.51) Omar Khayam reminds us that this moment is all we have. This is the moment our life is unfolding so this is the only moment we can live, learn, love, enjoy or experience anything. Desire, the dissatisfied foe of peace and contentment, is inherently preoccupied about the future. As such we miss our life and what there is to be appreciated in any given moment. We create a pervasive state of mind, always assuming that we will be happy in some other place, some other time. As an old saying goes, 'When we get *there* we realize there is no *there*.'

One of the greatest modern exponents of Sufism was Hazrat Inyat Khan (1882–1927). He was born in Baroda, India. He was deeply spiritual and devotional from an early age and found an outlet for this through his love of music and poetry. His spiritual leanings took a turn towards Sufism after he had a premonition about meeting his future teacher, Muhammad Abu Hashim Madani. Khan, having an academic disposition, went to hear Madani's instruction on spiritual and metaphysical matters and took a notebook with him. Madani asked him to put his notebook away, telling him that knowledge of spiritual matters is written in the heart, not on paper. Khan later went on a pilgrimage to many of India's holiest sites and settled for a time in Kolkata, until the death of his father. Soon after this Madani died, but before passing he left Khan with the instruction to harmonize the East and West and to take the teachings of Sufism abroad. In 1910 Khan and his brother sailed to the United States where, through musical performances, dance and poetry, he preached Sufism and the unity of all humankind.

As Khan himself said, 'The Sufi sees the truth in every religion.'

With failing health due to his relentless schedule of teaching and travel, Khan returned to India in 1926. However, his fame preceded him and his

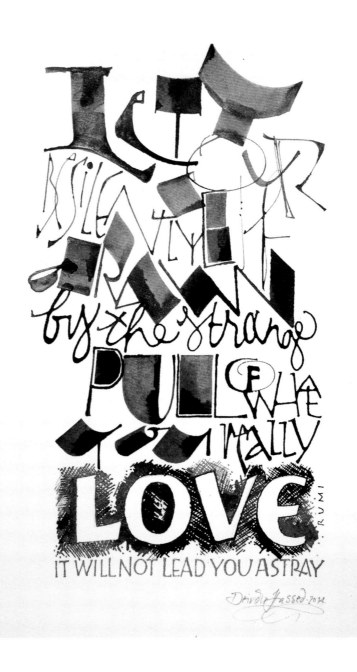

Let Yourself Be
Silently Drawn
(see text on p. 42)

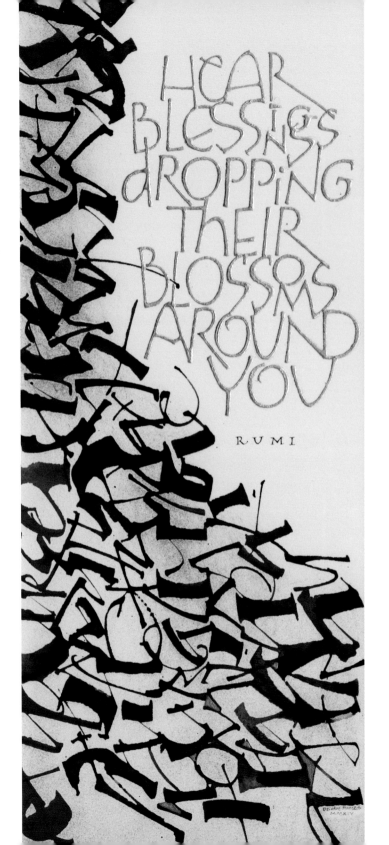

HEAR
BLESSINGS
dROPPING
THEIR
BLOSSOMS
AROUND
YOU

RUMI

Hear Blessings
(see text on p. 43)

Opposite: To Find a Pearl
(see text on p. 43)

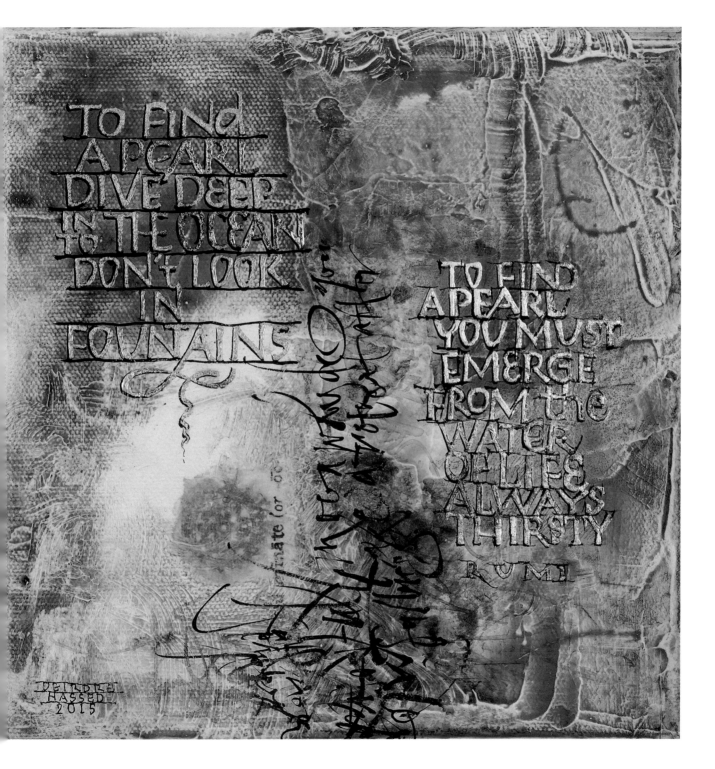

TO FIND
A PEARL
DIVE DEEP
INTO THE OCEAN
DON'T LOOK
IN
FOUNTAINS

TO FIND
A PEARL
YOU MUST
EMERGE
FROM the
WATER
OF LIFE
ALWAYS
THIRSTY

RUMI

DEIRDRE
HASSED
2015

The minute
I heard my
first LO♥VE
story, I started
looking for you,
not knowing
how blind I
was. L♥VERS
don't finally
meet somewhere,
They're in EACH
OTHER ALL ALONG.

RUMI ♥

For Garry & Lorraine
with love from
Craig & Deirdre

· SCRIPSIT · DEIRDRE HASSED · 2014

When Two Lovers Meet
(see text on p. 43)

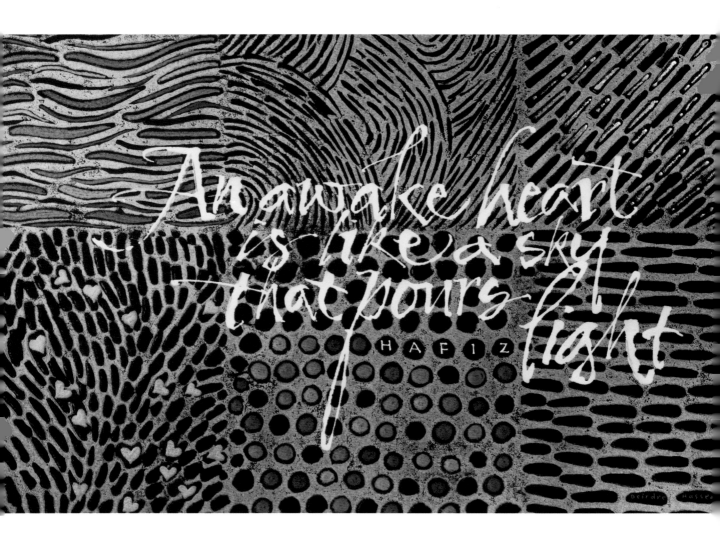

An Awake Heart (see text on p. 43)

Opposite: Be Happy For This Moment (see text on p. 44)

Be happy
for this moment.
This moment
is your life.

OMAR
KHAYYAM

resources were further drawn upon and depleted, which contributed to his untimely death.

The quote, ***Enter Unhesitatingly Beloved*** (p.54), can be read as a passionate, romantic message, but on a deeper level it communicates much of the essence of Khan's and Sufism's message: that of intense longing to be one with the only true beloved, the Divine. As with Shakespeare's sonnets, God is often represented symbolically in Sufi poetry as the beloved in a male or female form. To be drawn only to the romanticism and overlook the deeper spiritual message is to do a great disservice to Shakespeare and to Sufi poetry, but to speak the poetry in courtship, while at the same time remembering its deeper meaning, honours the poet and the Sufi message.

I Searched But I Could Not Find Thee (p.55) draws on the same metaphor of the pearl used by Rumi. It brings home the message that what we seek is within, not outside of ourselves. Where do we look for happiness, for love, for wealth? Generally, in things outside ourselves. But this is a restless, endless and ultimately futile search. This profoundly important message of looking within is found in virtually every wisdom tradition, from the biblical 'The kingdom of God is within you', to the Upanishad's 'Now and again, a daring soul looks back and finds himself', to the Buddhist tradition's 'Peace comes from within. Do not seek it without', to the contemporary literary tradition as, for example, in Rudyard Kipling's story from *Surgeons and the Soul* about man being unable to find God because it is hidden inside himself.

Of all Middle Eastern authors, possibly the most famous is Kahlil Gibran (1883–1931). He was born in Lebanon but migrated with his family to America in 1895. His book, *The Prophet*, has become a modern classic and he is held by some to be the third best-selling poet of all time.

The Prophet **provides wise counsel for just about every question and concern arising in modern life.**

His most widely quoted passages relate to love and are very commonly recited at weddings. Kahlil Gibran was brought up as a Christian in the Catholic Maronite tradition but he was also very conscious of his cultural, ethnic heritage. His mysticism can easily find a home in Christian, Islamic, Sufi and Judaic philosophies, which may be part of the reason he has such universal appeal. The renewed popularity of *The Prophet* in the 1960s may have contributed significantly to the resurgence of interest in the West in the Sufi poets like Rumi and Hafez.

Love One Another (p.56) speaks to that interesting balance arising from two people who fall in love and decide to spend their lives together. Through the rich use of metaphor Gibran communicates how two people can exist as one but at the same time be individuals. The vibrating strings of a lute intimate harmony. The pillars of a temple intimate strength. Sustenance is intimated by the sharing of bread. In each case the whole is greater than the parts, but the parts still exist.

There is unity in diversity. The dual inherent unity underpins life and love but, at the same time, diversity is an inescapable expression of the world.

A lack of space for people to grow and express their individual qualities may well stifle them, but a lack of connection between two people means never transcending our individual, separate existence.

Wisdom traditions have long seen a connection between love and beauty. Where we see beauty, love is not far behind.

In philosophical traditions like the Sufis or the Greek Platonic tradition, beauty is a transcendent quality. Although one and eternal, it finds expression in the beauty of worldly things. These beautiful physical things are not beauty itself, although we often pursue them as if they were, but they hint at a beauty that lies deeper than the physical. The physical things come and pass, like a beautiful flower, artwork or face, but beauty itself does not pass, nor is it diminished by the passing of physical forms. It is with this in mind that Kahlil Gibran writes the simple words for *Beauty is not in the Face* (p.57). The light reflected in the heart hints at that deeper, transcendent consciousness which is the true beloved. These words are clearly echoed in Shakespeare's immortal line from Romeo and Juliet, 'But soft! What light through yonder window breaks? It is the east and Juliet is the sun.'

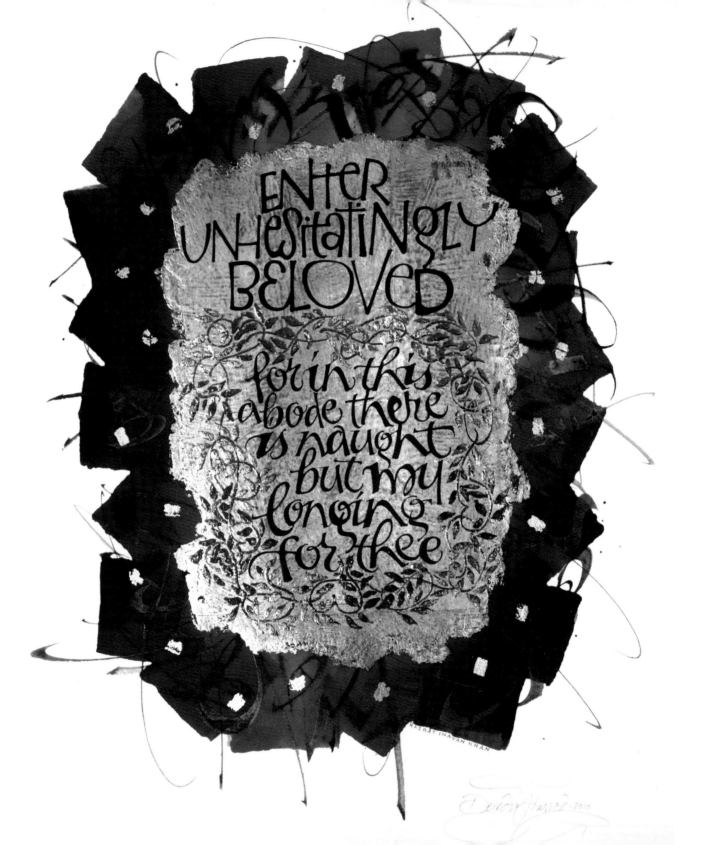

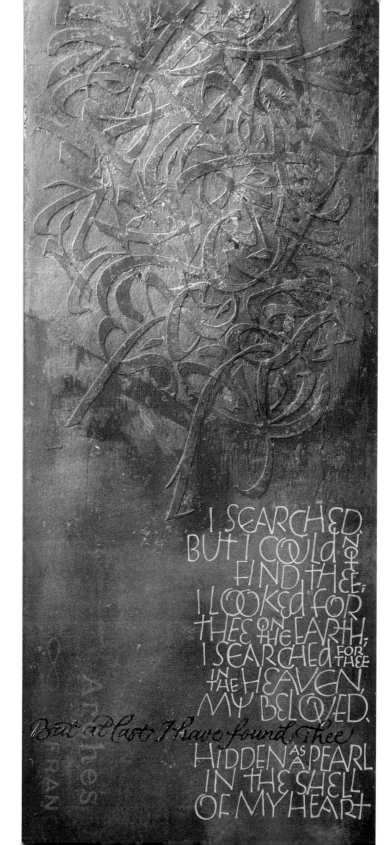

Opposite: Enter Unhesitatingly Beloved (see text on p. 52)

I Searched But I Could Not Find Thee (see text on p. 52)

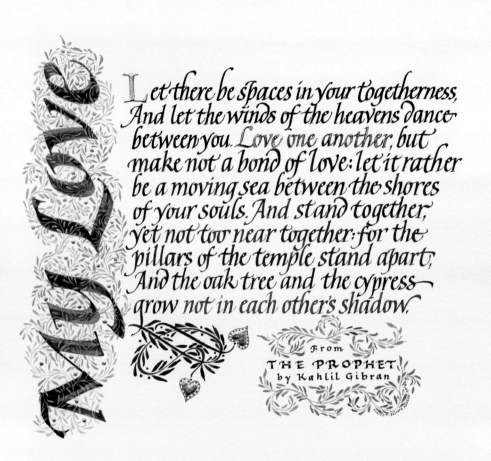

Let there be spaces in your togetherness, And let the winds of the heavens dance between you. Love one another, but make not a bond of love: let it rather be a moving sea between the shores of your souls. And stand together, yet not too near together: for the pillars of the temple stand apart, And the oak tree and the cypress grow not in each other's shadow.

From THE PROPHET by Kahlil Gibran

Love One Another (see text on p. 52)

Opposite: Beauty is not in the Face (see text on p. 53)

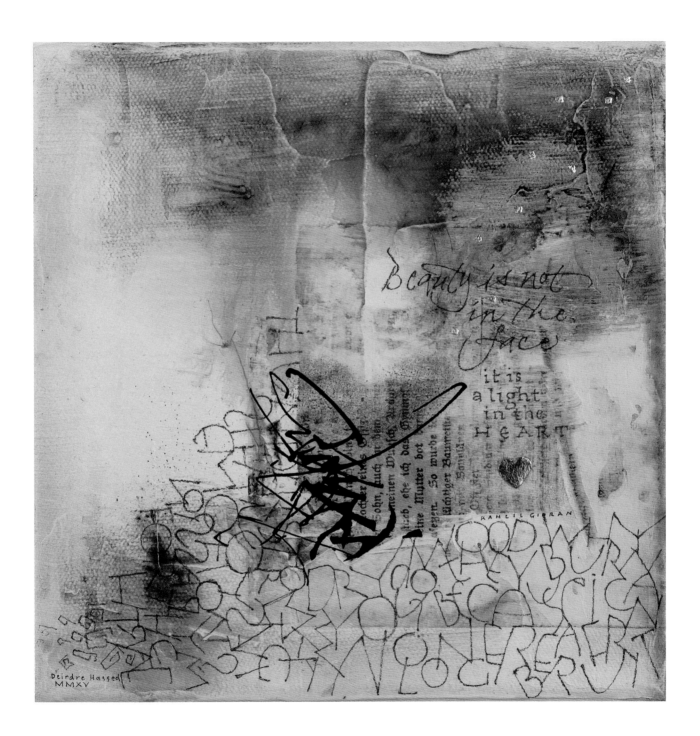

Buddhism

Buddhism arose from the Indian philosophical tradition in the 5th century BCE, around the same time that Socrates and Plato lived in Greece. Siddhārtha Gautama, who later became the Buddha, was the man who started Buddhism. He was probably born into royalty in Nepal but later lived in northern India. He led a sheltered life. It is said that one day he left the palace and saw sickness, poverty and death for the first time, which led him to deep and profound reflection on the nature of suffering and transience. He subsequently left his privileged existence of sensual indulgence to take up an extreme ascetic life, before realizing a more moderate 'middle way' to enlightenment.

There are many Buddhist sects but some of the common teachings relate to suffering, transcendence and liberation. They also teach rebirth, as did the ancient Greek, Judaic and Indian traditions.

Some people describe Buddhism more as a philosophy than a religion. It is often seen as being non-theistic, in that it doesn't speak of God, but the difference may be semantic rather than actual.

When a Buddhist refers to the empty, formless consciousness, which equates to our being or existence, it bears an uncanny resemblance to the self spoken of in the Vedic tradition.

They also call this self, God. It is nothing in that it is no single thing. We cannot see it because it is the very part of us that is looking.

We can see consciousness reflected back to us by the world and people around us.

Thus, when monotheistic spiritual traditions speak about the omnipresent, omniscient, omnipotent transcendent God it bears more than a passing resemblance to these Eastern descriptions of self or consciousness.

The word 'Buddha' comes from a Sanskrit word, *buddhi*. This refers to the deeper, wiser and more intuitive aspect of mind, with which a person becomes enlightened.

The basic tenets of Buddhism are based on the Four Noble Truths: The Truth of Suffering, The Truth of the Cause of Suffering, The Truth of the End of Suffering, and The Truth of the Eightfold Path leading to the End of Suffering.

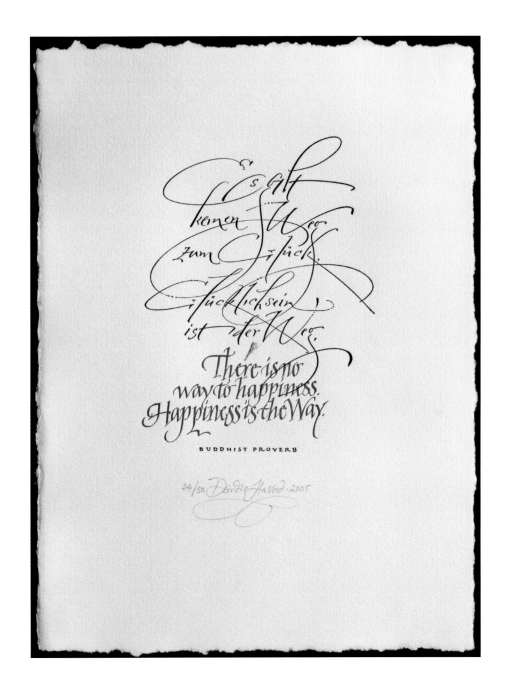

There is No Way to Happiness (*see text on p. 60*)

The Eightfold Path has three main divisions which cover wisdom (right view and resolve), moral virtues (right speech, action and livelihood) and meditation (right effort, mindfulness and concentration).

There is No Way to Happiness (p.59) is translated into English and German. Like so many other philosophical truths, the paradox confounds our usual assumptions about the nature of things. For example, we look for many ways to happiness. We search for it in many places — in possessions, wealth, success, relationships … All of these things are passing and hence we find ourselves in a constant cycle of getting what we don't have, trying to hold on to it, losing it, and then grieving over our loss. Happiness seems to always be deferred to the future when we will have everything we want and avoid everything we don't want. Contrary to our best efforts, this may be a recipe for unhappiness. In reality, happiness may actually be an inner state and a natural expression of the free mind and heart, unencumbered by attachments and desires.

True happiness is 'the way'. It is here and now. It is not dependent on anything other than our being.

Another Buddhist proverb, *All That We Are* (p.62), highlights the importance of what we think or what thoughts and emotions we decide to direct our attention to. When we think something once, twice, three times or more, we engrain habits of mind, just like ruts in the ground, that make it harder and harder to steer away from. We feed angry thoughts and we reap the effects of that. We practise compassion and we reap the effects of that. Interestingly, modern neuroscience, through the discipline of neuroplasticity, is coming to a very similar conclusion.

What we think, so we become. The consciousness will simply take the form of what it is fed on, for better or for worse.

Therefore, it takes a conscious and discerning mind to choose wisely what to give our attention to.

Yuan Sou's *The Unsurpassed Ultimate Truth* (p.63) demonstrates a love and immersion in nature reminiscent of Thoreau's *Walden*, a reflection on simple living in natural surroundings, or Shakespeare's quote in *As You Like It*, 'And this our life, exempt from public haunt, finds tongues in trees, books in the running brooks, sermons in stones, and good in everything. I would not change it.'

The natural world has great potential to connect us with the oneness and rhythm of life itself.

If we are present enough to recognize it, every sight, sound and experience speaks to us of a consciousness, underlying and enlivening everything. No doubt this feeling of connection to the natural

environment goes to the heart of indigenous culture's belief that connection with place and self are an inseparable part of the whole ecosystem. Sadly, that connection is all but lost for the vast majority of urbanized people these days, especially the young who may never have been in a natural environment.

Thich Nhat Hanh (1926–) is a Buddhist monk and peace activist. He was born in Vietnam and later set up a community in France. He is well known in the West for his writings on Buddhist philosophy and practical mindfulness. The world has become noisier and more assertive these days but *Kissing the Earth With Your Feet* (p.64) reminds us of the gentle and peaceful way we could live our lives.

> **To walk and only leave serenity in our wake, as if we were kissing the earth with our feet, one needs lightness of being, to be without attachment and to live with care and compassion for all.**

We may have a taste of what this means if we should ever be so lucky to be in the presence of a wise soul. They leave the gentlest but most profound impression behind.

Tenzin Palmo (1943–) is a nun in the Tibetan Buddhist tradition. Born Diane Perry in Hertfordshire, England, she was drawn to Buddhism at an early age. When she was 20 she travelled alone to India and began her quest for ordination into the Vajrayana tradition. She achieved this in 1964. Being a nun in an environment dominated by male devotees was anything but easy and she experienced much discrimination. In 1976 she withdrew to a cave high in the Indian Himalayas where she remained in retreat and intensive meditation for the next 12 years. Her determination and unique story inspired Vicki McKenzie to write a book about her life called *Cave in the Snow*. Now she travels and teaches widely around the world. It is pretty clear that someone who could live in such austere circumstances for so long understands how to give up attachment to worldly possessions and comforts.

In *Cultivate Contentment* (p.65) Tenzin Palmo gives very direct and practical advice on how the mind can find contentment and free itself from its constant desire for attaining more.

> **Poverty lies not in having few possessions but in wanting them.**

Such mental renunciation opens up the door to generosity and lightness of being. Her advice echoes Socrates' words while he was standing in the marketplace: 'How much can I do without?' Do we all have to live in a cave to achieve what Tenzin Palmo achieved? No, we can practise right where we are (but going to a cave probably speeds the process up somewhat).

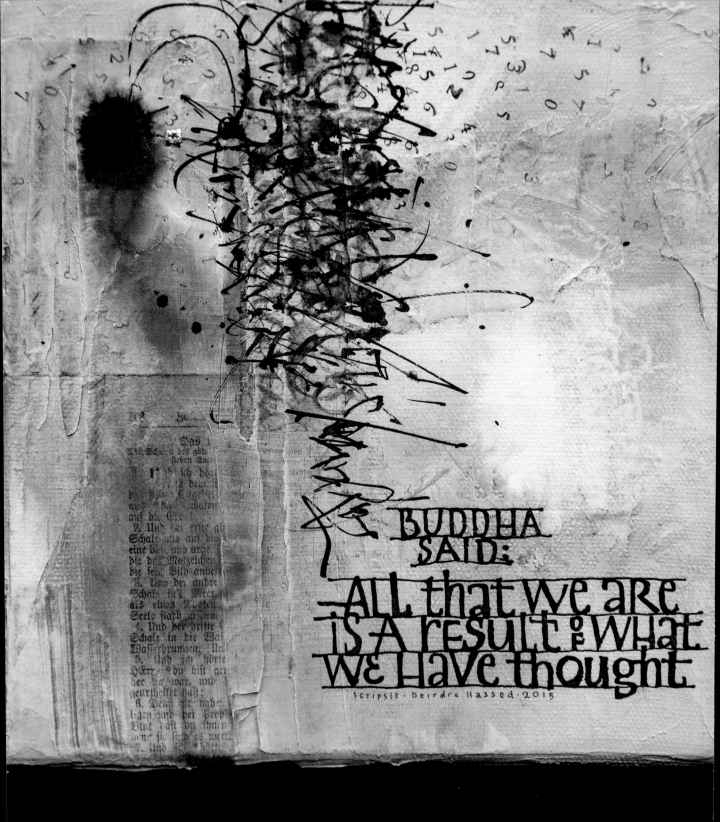

BUDDHA
SAID:

ALL that we are
is A result of WHAT
WE HAVE thought

Scripsit · Deirdre Hassed · 2015

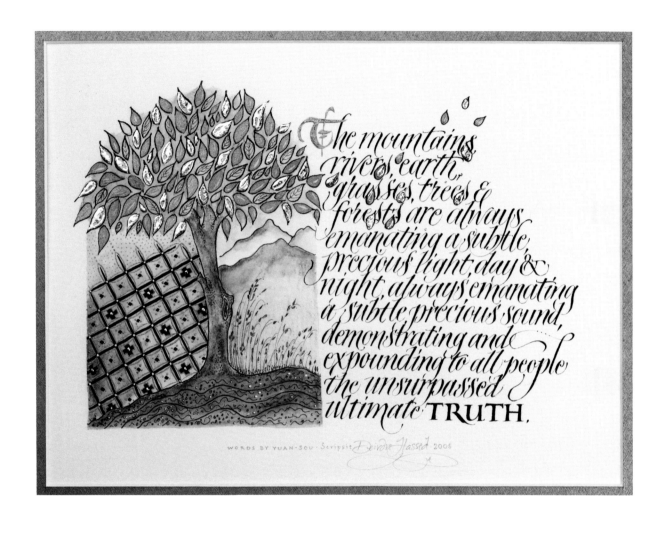

The mountains, rivers, earth, grasses, trees & forests are always emanating a subtle, precious light, day & night, always emanating a subtle precious sound, demonstrating and expounding to all people the unsurpassed ultimate TRUTH.

WORDS BY YUAN-SOU · Scripsit Deidre Hassed 2005

Opposite: All That We Are (see text on p. 60)

The Unsurpassed Ultimate Truth (see text on p. 60)

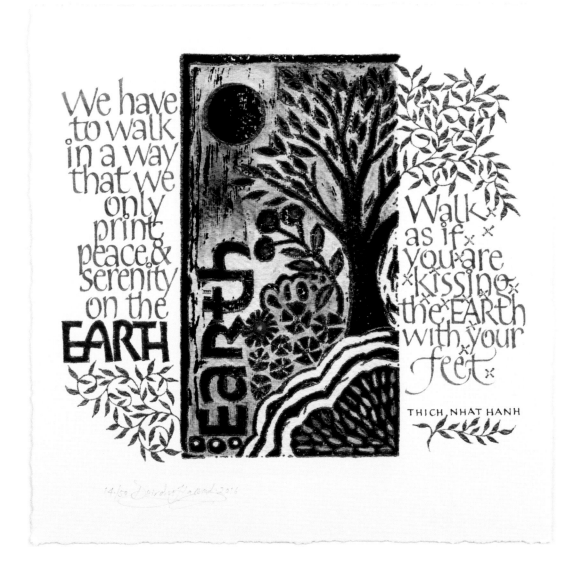

We have to walk in a way that we only print peace & serenity on the EARTH

Walk! as if you are kissing the EARTH with your feet

THICH NHAT HANH

Kissing the Earth With Your Feet (see text on p. 61)

Opposite: Cultivate Contentment (see text on p. 61)

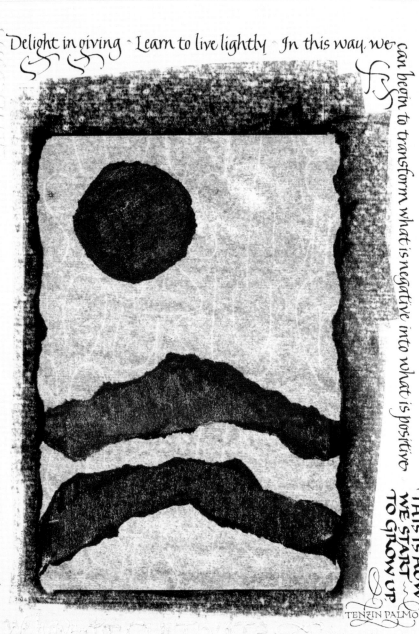

Delight in giving ~ Learn to live lightly ~ In this way we can begin to transform what is negative into what is positive

We really don't need much ~ When you know this, the mind settles down

THIS IS HOW WE START TO GROW UP.

TENZIN PALMO

Be Still Like a Mountain

Lao Tzu's date of birth is unknown. Although historical references are sketchy, it is said that he lived in 6th century BCE around the time of Confucius, and may have been a contemporary of his. Although some people question if he was a real historical figure, the general consensus is that Lao Tzu founded Taoism and wrote the classic philosophical text the *Tao Te Ching*, which laid out the principles of Taoist teachings. Taoism is full of paradoxes that don't make sense to conventional ways of thinking. For example, in **Be Still Like a Mountain** (opposite) Lao Tzu exhorts us to be still and flow at the same time. How can that be? If, however, one part of us is creature and another part of us is witness, then the creature needs to be like a free-flowing river but the witness is still like a mountain.

We need to live life centred in that stillness, and be 'the still point of the turning world'.

From there arises clarity, wisdom and equanimity, as well as an ability to live worldly life fully but lightly.

Hsing Yun (1927–) is a Chinese Buddhist monk who founded a new religious order called Fo Guang Shan. He is a somewhat unusual and controversial monk in that he is quite politically active and unafraid to express his views, such as those supporting the One China policy, although he has been a little more circumspect about his support for reconciliation between China and the Dalai Lama. Hsing Yun equates **The Four Treasures of**

Life (p.68) — endurance, generosity, tolerance and contentment — with power, wisdom, compassion and wealth respectively. The one who cannot endure will not prevail. The one who is not generous is not wise. The one who cannot be tolerant is not really compassionate. And the one who is not content is always poor, no matter how much money or how many possessions they have.

The true power is ENDU[R]

The true wisdom is GEN[E]

The true compassion is TO

The true wealth is CON[T]

ENDURANCE, GENER
TOLERANCE & CONTE
ARE THE FOUR TREASU

The Four Treasures of Life
(see text on p. 67)

Vedic (Indian) tradition

Veda is a Sanskrit word meaning 'knowledge', and it may also be the etymological root of our word for 'wisdom', traced back through old English words like 'wis', 'wit' and 'wid'. The Veda is said to be the knowledge underpinning the laws of the universe and was formulated in what we call the Vedas, which is a series of books.

The Vedas are the storehouse of spiritual and practical knowledge that is the foundation of the Indian philosophical and religious tradition.

The Vedas can be traced back to at least the second millennium BCE but nobody really knows how old they are. It is likely they were transmitted through an oral tradition for centuries before they were written down as four main books: the Rig, Sama, Yajur and Atharva Veda. The collection of philosophical and spiritual texts, including the Upanishads and the *Bhagavad Gita,* is part of the wider collection making up the writings that are called the *Vedanta.*

The Vedic's ultimate aim is for the liberation of the soul and the secondary aim is to live a happy and harmonious
life, although it is difficult to separate those two objectives.

The famous *Bhagavad Gita* is the spiritual and philosophical heart of a much larger work called *The Mahabharata*, attributed to Vyasa. This is one of the two main epics of Indian literature, the other being the *Ramayana*. As with the Greeks, such epics were a way of transmitting wisdom through allegory and story telling. *The Mahabharata* is the story of a great war on the battlefield of Kurukshetra between the allies of two mighty families, the Pandava and the Kaurava. The battle between good and evil, right and wrong can be seen as an actual military campaign but it is better understood as the inner battle against greed, ignorance and attachment within our own minds and hearts. **He Enjoys Happiness** (opposite) comes from a speech given by Bhishma as he lies on his bed of arrows. Paradoxically, in the midst of the conflict, Bhishma advises that only he or she is happy who lives a virtuous life, is forgiving and shows compassion for others. The one who gains the whole world, but has sold or lost their own soul, is not happy at all, no matter what they believe. They will find no peace or contentment.

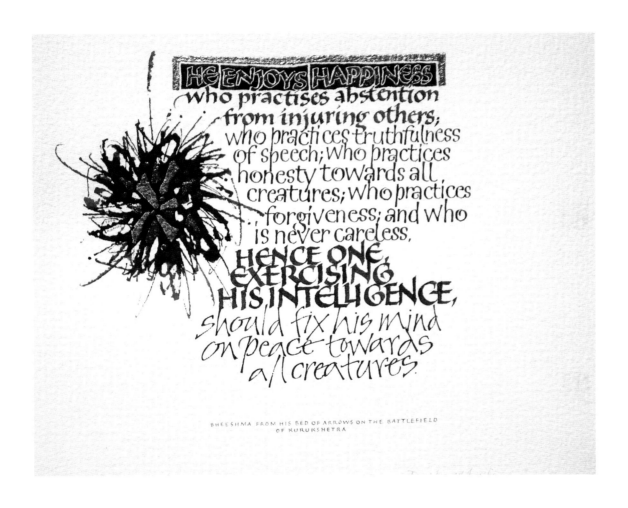

HE ENJOYS HAPPINESS
who practises abstention
from injuring others;
who practices truthfulness
of speech; who practices
honesty towards all
creatures; who practices
forgiveness; and who
is never careless.
HENCE ONE,
EXERCISING
HIS INTELLIGENCE,
should fix his mind
on peace towards
all creatures.

BHEESHMA FROM HIS BED OF ARROWS ON THE BATTLEFIELD
OF KURUKSHETRA

He Enjoys Happiness (see text on p. 70)

Following page: Bhagavad Gita: XVI:1–3 (see text on p. 74)

Fearlessness; purity of being;
Steadfastness in Spiritual knowledge;
Charity; Self-control; Sacrifice; Study of
Sacred texts; austerity; Straightforwardness;
Harmlessness; Truth; absence of anger;
Renunciation; tranquillity; absence of calumny;
Compassion for all beings; freedom from desire;
Gentleness; modesty; Steady determination;
Vigour; forgiveness; fortitude; cleanliness;
freedom from envy and pride...
these are the qualities of a man's divine nature!

BHAGAVAD GITA XVI

भिजातस्य भारत ॥

The *Bhagavad Gita* — *gita* meaning song — comes at a crucial stage of the *Mahabharata* and relates the conversation between the warrior Arjuna and his charioteer and teacher Krishna. Before being able to fight for truth, Arjuna needs to clarify his understanding and so seeks wisdom from Krishna. For example, is the fight really righteous? How can he justify slaying the opposing army, many members of which are from his own friends and family? The verses from the **Bhagavad Gita: XVI:1–3** (p.72) enumerate the so-called 'godly qualities' of a divinely inclined soul. They speak of many things, including the importance of a mind that is purified and directed towards spiritual or higher knowledge, a mind and heart that are at peace, an attitude of kindliness, care for one's fellow creatures and the virtuous conduct that flows from that, as well as the need for self-discipline and restraint to avoid excessive indulgence in the sensory world. For an aspirant, cultivating these qualities requires patient and hard work because the mind is habitually attracted to and infatuated with worldly things.

Ultimately, when the mind is free of its habitual attractions, such qualities are a natural and effortless expression of a harmonious and liberated soul.

The virtue of such a person has no self-consciousness or ego about it.

The Vedic literature is full of prayers for all occasions. The **Gayatri Mantra** (p.76) is among the most famous and sacred of all Vedic prayers. It begins with homage to the one, universal being. The underlying unity of the universe is acknowledged by recognizing that there is only one body, one mind and one spirit of which we, as individuals, share a tiny part.

The mind of the aspirant aspires to be drawn to contemplation of the Supreme, which illuminates the whole universe.

That radiant consciousness is not something separate from us because it is the very same consciousness in us that is illuminating all we see. It is in light of that knowledge that our mind and heart should be inspired.

Among the many Upanishads there are said to be ten that are most important. These are sometimes called the Principal Upanishads. The *Chandogya Upanishad* is one of these. **In This Body** (p.77) appears in Chapter 1 and, like many Upanishadic writings, it is shrouded in mystery, paradox and metaphor. There is clearly no one way of interpreting such texts, but one aspect of what this passage may be speaking about is that everything that is in the universe is also in us. Just like Emerson's aphorism 'the all is in each particle', the whole universe can be found within.

The consciousness embracing our body and mind also contains the universe, not the other way around.

Therefore the physical universe and subtle mind, though they look vast, are contained within consciousness.

Another of the ten Principal Upanishads, and possibly the most famous and widely translated, is the *Katha Upanishad*. It tells the story of Nachiketas, who is the son of a sage Vahasrava. Nachiketas meets Yama, who is the Indian deity of death. They have an extensive conversation covering the nature of man, knowledge, the soul or self, and liberation from death. The most widely used philosophical and literary metaphor for consciousness is light. In this passage, *By His Shining All This Shines* (p.80), the relative reality and importance of the physical world are weighed against the importance and reality of God, the universal consciousness or being.

It is by God's reflected light that anything else, even the sun, exists and shines.

That the physical world is just a shadow of a far greater light is an image used extensively by Plato in *The Republic* and by the Sufis, such as Omar Khayyam.

It is not really known when Patanjali, the great Indian Sanskrit scholar and author, lived. It was probably around the 2nd century BCE although some believe that it may have been as late as the 3rd century CE. Patanjali was the author of the Yoga Sutras, famous among yoga practitioners, as well as the Mahābhā ya, a treatise on Sanskrit grammar and linguistics. He also wrote on Ayurveda, the ancient

Indian system of medicine. In *When You Are Inspired* (p.81) Patanjali writes of the latent wisdom and power within us which can be unlocked when we are inspired by a cause greater than ourselves. It is as if the calling connects the individual's mind with a universal mind — a kind of storehouse of energy and wisdom.

Connecting with the universal within us leads to a sense of expansion as we tap in on potential we may never have known existed.

Being universal, such a capacity is experienced as impersonal, hence the humility with which great souls and creative geniuses speak of their own personal powers and the awe with which they speak of this universal creative intelligence.

Ramana Maharshi (1879–1950) was born into a humble but spiritually devout family in southern India. His life was relatively uneventful although it is likely he had spiritual and meditative experiences from a young age. At sixteen it is said that he had a sudden, spontaneous and profound spiritual experience as his mind dove deeply into the contemplation of death and transience. From this intense experience arose an intense longing to renounce the world and pursue silence and deep contemplation at the shrines and caves on the holy mountain Arunachala. He made his way there, where he lived for the rest of his life. After some years, as people congregated around him, Ramana eventually broke his silence and began to teach. Soon, an ashram

Om bhūr bhuvaḥ svaḥ
tat savitur vareṇyaṃ
bhargo devasya dhīmahi
dhiyo yo naḥ pracodayāt

ॐ भूर् भुवः स्वः ।
तत्सवितुर्वरेण्यं
भर्गो देवस्य धीमहि ।
धियो यो नः प्रचोद्यात् ॥

Gāyatrī Mantra

Body of all • Mind of all • Spirit of all
May we meditate on the Supreme:
On the all-pervading radiance of
the ultimate source of divine light.
May He inspire the innermost thoughts of our hearts.

Gayatri Mantra (*see text on p. 74*)

Opposite: In This Body (*see text on p. 74*)

In this body, in this town of Spirit,
there is a little house shaped like a lotus,
and in that house there is a little space.
What is there?
Why is it so important?
There is as much in that little space
within the heart, as there is
in the whole world outside.

HEAVEN·EARTH·FIRE·WIND
SUN·MOON·LIGHTNING·STARS
whatever is and whatever is not,
everything is there.

CHANDOGYA UPANISHAD

grew up around him and Ramana became one of the most revered sages of modern India. This collection of three quotes from Ramana Maharshi speak to some of the central tenets of his teaching. Firstly, to discover what is constant in us we must learn to watch our transient experience without attachment to it. Secondly, there is only one self. The deluded mind creates 'other' by identifying itself with superficialities. From that arises fear and conflict. Thirdly, the noisy agitated mind obscures insight. True knowledge arises in and is transmitted by pure, awake silence.

Nisargadatta Maharaj (1897–1981) was born a humble householder from Mumbai, India. His parents were very religious but his father died when Nisargadatta was eighteen and he began working as a merchant to support his mother and siblings. He met the person who became his guru when he was 27. His teacher told him that in reality he was not what he took himself to be — the mind, body and ego — but rather he was the underlying and unchanging existence or awareness, which he called the 'I am', echoing the passage in the Bible when Moses asks for God's name and is told, 'I am that I am'. Nisargadatta devoted himself to remembering that and it is said that in three years he became liberated. Soon Nisargadatta attracted his own students, one of whom was Maurice Frydman, who recorded his talks. With the publication of *I Am That* in 1973 by Frydman, Nisargadatta gained a worldwide following.

You are the Love Between the Two (p.82) speaks simply of the importance for two people, if they are to be true lovers, to transcend individual differences.

In order to do that the people must know themselves as they really are, beyond labels and roles of male and female, husband and wife. It is love that binds them and from that flows order and domestic happiness. A theme continually returned to by Nisargadatta was to rest as the still, ever-present, unchanging observer of our moment-by-moment experience.

That which is constant in us is the awareness itself, the true I, and not all the passing states of mind, body and circumstance that we are aware of.

Like the audience of a play, or the still point of the turning world, the witnessing consciousness watches without doing anything or being involved in what it observes. Yes, body and mind may act, but we are the witness of the actions.

Many wisdom traditions use riddles. For example, in the Zen tradition Koans are often used to explain the unexplainable. Similarly, Nisargadatta's quote, *True Awareness* (p.83), seems not to make sense when looked at from our usual perspective. It is a paradox that can only be solved if we understand the distinction between the self that is constantly doing — walking, acting, speaking, thinking, feeling, reacting etc. — and the self that is simply aware and does nothing. The one is changing and the other constant. The one is the actor in the play of life and the other is the silent audience of the play. The one is constantly becoming and the other is forever being. The one suffers the 'slings and arrows

of outrageous fortune' and the other is unaffected by all that takes place in mind and body. The one sees happiness as pleasure and love as conditional whereas the other experiences bliss as pure awareness and love as unconditional.

This understanding cannot arise through imagination or intellectualization, but only through direct experience.

Then the apparent riddle or paradox is solved. Adi Shankara was an Indian sage who lived in the 8th century in India. He was a gifted scholar and had a profound intellectual capacity to penetrate the heart of any philosophical subject. He travelled widely in India, engaging with pundits wherever he went, and in his short life of 32 years had a significant effect of revitalizing the Indian philosophical tradition of *advaita vedanta* — the knowledge of unity. Four philosophical seats were set up around India in his name and that tradition has continued to this day, with the Shankaryacharya being teachers in the tradition of Shankara.

Shantananda Saraswati (1913–1997) was born in the Basti district of India to a Brahmin family. Brahmin is a Hindu caste specializing in teaching, priests and protectors of scared learnings. It is said that Shantananda was the son of the sister of the Shankaracharya swami Brahmanand Saraswati, whose devotee he became. Brahmanand Saraswati was a contemporary of the Maharishi Mahesh Yogi who brought Transcendental Meditation to the West. Brahmanand Saraswati initiated Shantananda as sannyasi (swami) in January 1951 and then he was later installed as a Shankaracharya of Jyotir Math on 12 June 1953. Throughout the rest of his life he taught widely throughout India but also influenced many Westerners who regularly came to visit him in India for audiences. *The Desire for Truth is Like a River* (p.84) speaks of how the desire for truth will always find a way past and around every obstacle. Those obstacles are not just the challenges we meet in worldly life but can also be philosophical and religious traditions and systems that have become fixed in dogma and ceremony.

Spiritual traditions arise from the longing for truth but soon become static like mountains.

The seeker has to go past them and continue until merging with the ocean, the truth itself.

In 1913 Rabindranath Tagore (1861–1941) was the first non-European to win a Nobel Prize for Literature. He was a noted Indian poet, sometimes referred to as the 'Bard of Bengal', and was enormously influential in bringing the Indian culture to the west. Apart from his literary achievements, he was also politically active as an advocate for internationalism and Indian independence from British rule. Although his poetry was beautiful and had its own unique style, it was his philosophical and spiritual insights that gave it such

न तत्र सूर्यो भाति न चन्द्रतारकं
नेमा विद्युतो भान्ति कुतो ऽयमग्निः।
तमेव भान्तमनुभाति सर्वं
तस्य भासा सर्वमिदं विभाति॥

There the sun cannot shine
and the moon has no lustre;
all the stars are blind;
there our lightnings flash not,
neither any earthly fire.
For all that is bright is but
the shadow of His brightness
and by His shining all this shines.

KAȚHOPANIȘAD 5:15

By His Shining All This Shines (see text on p. 75)

Opposite: When You Are Inspired (see text on p. 75)

When you are inspired
by some great purpose,
some extraordinary project,
all your thoughts break
their bonds; your mind
transcends limitations,
your consciousness expands
in every direction, and you
find yourself in a new,
great & wonderful world.
Dormant forces, faculties
& talents become alive,
and you discover yourself
to be a greater person by
far than you ever dreamed
yourself to be.

PATANJALI

A/P 2 Deirdre Hassed · 2011

In Marriage
you are neither
the husband
nor the wife,
YOU ARE THE

BETWEEN THE TWO.
You are the clarity
and the kindness
that makes everything
orderly & happy.

SRI NISARGADATTA MAHARAJ
I AM THAT

Opposite: You are the
Love Between the Two
(see text on p. 78)

True Awareness
(see text on p. 78)

True Awareness

IS A STATE OF
PURE WITNESSING,
without the least attempt
to do anything about the event
witnessed. Your thoughts
and feelings, words & actions
may also be a part of the event;
you watch all unconcerned
in the full light of clarity
and understanding.
You understand precisely
what is going on, because
it does not affect you.
It may seem to be an attitude
of cold aloofness, but it is not
really so. Once you are in it,
you will find that you love
what you see, whatever may
be its nature.
This choiceless love
is the touchstone
of awareness.

SRI NISARGADATTA MAHARAJ · 'I AM THAT' PAGE 382

IF THERE IS A DESIRE FOR TRUTH

no doubt there will be barriers, but in the course of time they will be overcome. The desire for Truth is like a river, like the river Ganges. She starts somewhere with a small beginning, facing all sorts of high mountains which hold her up; but she fills up and flows over them, intertwines around them for nearly two hundred miles of high, low and deep mountainous ranges, and she finds her way to the ocean to which she belongs. These mountains are also there in search of Truth, but have now become established as traditions and cannot move. Even in their earnestness they become obstacles, like all the traditions of philosophical or religious thought. They lead to a point & stop.

One need not be lured by high peaks nor sink into deep ravines, but keep going. One day Truth will be found. No attraction howsoever lofty, no obstacle, howsoever deep, could force a spirit to stop if the search for Truth is true. Spirit will find the Truth one day.

SHRI SHANTĀNANDA SARASWATI SHANKARĀCHĀRYA

The Desire for Truth is Like a River (see text on p. 79)

Opposite: Send Me the Love (see text on p. 87)

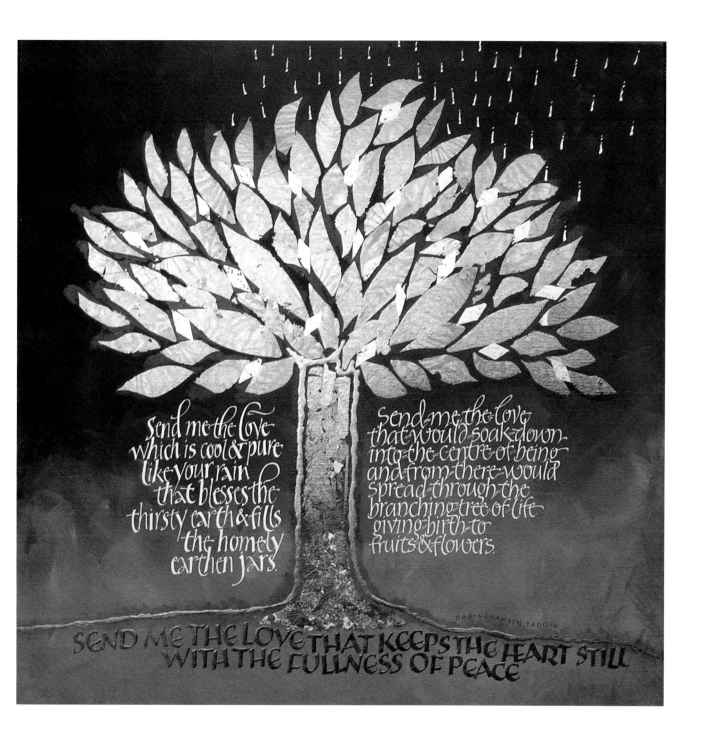

Send me the love
which is cool & pure
like your rain
that blesses the
thirsty earth & fills
the homely
earthen jars.

Send me the love
that would soak down
into the centre of being
and from there would
spread through the
branching tree of life
giving birth to
fruits & flowers.

RABINDRANATH TAGORE

SEND ME THE LOVE THAT KEEPS THE HEART STILL
WITH THE FULLNESS OF PEACE

THE WIND
IS BLOWING.
THOSE VESSELS
WHOSE SAILS ARE
UNFURLED CATCH
IT & GO FORWARD
ON THEIR WAY.
BUT THOSE WHO HAVE
THEIR SAILS FURLED
DO NOT CATCH
THE WIND.

IS THAT
THE FAULT
OF THE WIND?

VIVEKANANDA

depth. *Send Me the Love* (p.85) depicts a view of love that is somewhat different from many commonly held associations about it being hot and passionate, and of losing one's head.

The love that Tagore exhorts is cool, pure and deeply sustaining. It is life-giving, a love that keeps the heart still and at peace.

Such love can only be a transcendent, spiritual type of love, not the earthly love which is inconsistent, runs hot and cold, and is so much a favourite of popular culture and romantic movies.

The special relationship between the spiritual student and their guru (teacher) is much revered in India. One of the most famous student–guru relationships in modern history was that between the great spiritual teacher Ramakrishna, and his disciple Narendra, who later became Swami Vivekananda (1863–1902). Vivekananda was from Kolkata and an outstandingly intelligent, energetic and talented man who was also noted for his great presence in public speaking. Following Ramakrishna's death in 1886, Vivekananda was given the task of taking his master's teachings to the world, which he did with great enthusiasm and courage. His most noted travels were to the United States and included a famous speech he gave at the Parliament of the World's Religions in Chicago in 1893. Vivekananda's legacy still lives through the Ramakrishna Math and the Ramakrishna Mission that Vivekananda founded in

order to pass on Ramakrishna's teachings. *The Wind is Blowing* (opposite) conveys a metaphor important for the spiritual aspirant. God is sending His grace and wisdom all the time, but there are few people whose minds and hearts are open enough to catch it and make spiritual progress. The foolish person blames God for their lack of insight and bliss, not themselves.

Opposite: The Wind is Blowing

Indigenous and folk traditions

Through the uneducated and unseeing eyes of colonists, indigenous cultures may well have seemed primitive. They were little more than an inconvenience to be pushed aside as settlement of newly discovered lands spread. This view, however, ignored the sophisticated law, traditions and practical wisdom needed for such cultures to survive in harmony with nature for millennia. Because it wasn't written down it was easy to ignore. This early view of indigenous cultures said more about the minds and hearts of the conquerors than it said about those they conquered.

The teachings of the indigenous Australian Aboriginals are conveyed through symbolic stories, songs, dances and proverbs. The connections with the land, ancestors and other living creatures are central to identity and self — there is no separating them.

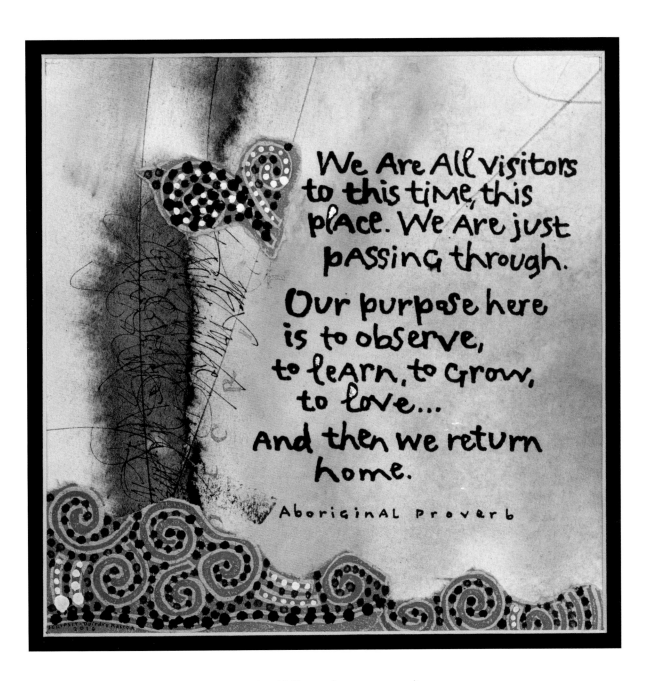

We Are All Visitors (see text on p. 93)

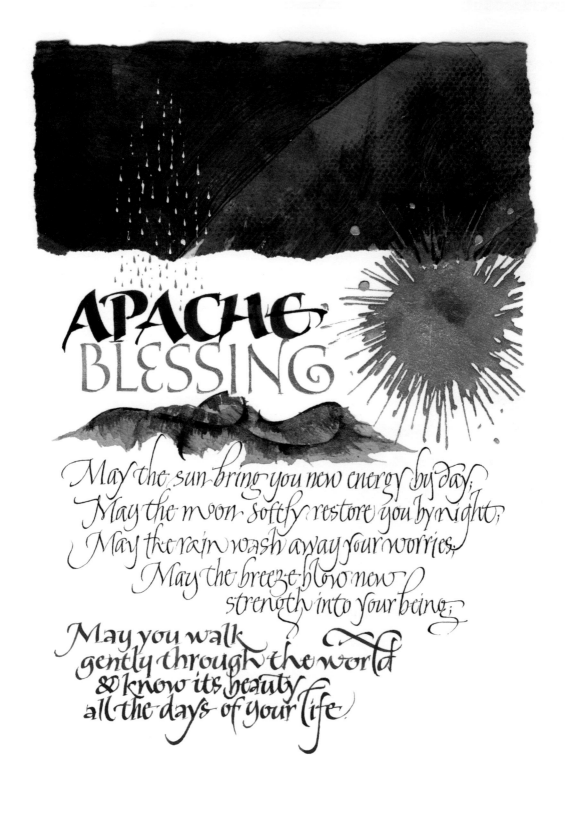

APACHE BLESSING

May the sun bring you new energy by day;
May the moon softly restore you by night;
May the rain wash away your worries;
May the breeze blow new
strength into your being;
May you walk
gently through the world
& know its beauty
all the days of your life

Opposite: Apache Blessing (see text on p. 93)

Maori Proverb (see text on p. 93)

May the road rise to meet you. May the wind be always at your back. May the sun shine warm upon your face; the rains fall soft upon your fields and until we meet again, may God hold you in the palm of his hand.

Celtic Blessing

We are All Visitors (p.89) speaks of the truth that we are merely travellers passing through. This transient worldly life is what we see, but it belies an existence that transcends time, person and place.

What gives life meaning on the way through is to observe, learn, grow and love, otherwise it is a wasted life.

Such a message can be found in all the world's great wisdom traditions.

The famous *Apache Blessing* (p.90) conveys a connection to land and nature, and the capacity for these elements to renew and enliven our spirits.

The beauty and kindness that are conveyed to the receiver of the blessing are matched only by the giver's implicit love of nature and its beauty.

The gentleness conveyed by Thich Nhat Hanh when he says we should 'kiss the earth with our feet' is similarly conveyed here by the words 'may you walk gently through the world and know its beauty'. If we really were able to connect with the beauty of nature then it would be hard to envisage us treating it so indiscriminately, as seems to be the case these days. We cannot blame the environment for the looming environmental crisis, only ourselves.

The New Zealand Maoris came from Polynesia via the ocean probably around the 13th century. That in itself is an extraordinary feat of seamanship. Over the centuries the Maoris evolved their own distinct culture and are known as brave warriors. With European settlement came times of conflict, but also the signing of the important Treaty of Waitangi in 1840. Since then, much has been learned about integration of the two races and although there are still important social disadvantages to be resolved, the Maori people and their culture and language hold an important and prominent place in modern New Zealand. This simple and short *Maori Proverb* (p.91) could be taken many ways. Perhaps one way of considering it is that we often associate shadows and darkness with fear and threat. Conversely, we associate the sun with wisdom and freedom from fear.

If we look towards the sun, if we have our mind turned towards wisdom, then we have the potential to live consciously, with insight and free of fear.

Like the Apache Blessing, the famous *Celtic Blessing* (opposite) is full of goodwill and kindness. It wills that every natural element should work with you, to nurture and sustain you, rather than against you. It finishes with the beautiful image of being held in the palm of God's hand, much like an adoring child would hold a fragile and beautiful butterfly in the palm of their hand.

The image of infinite power tempered with infinite benevolence is a rule by which we could all live, especially when dealing with vulnerable people and creatures.

Greek tradition

Although it is not always obvious to us, the influence of ancient Greek culture can be felt in virtually every aspect of modern life. The origins of our laws, philosophies and architecture can be traced back to Greek culture. The pinnacle of Greek culture took place throughout the 5th to 4th centuries BCE and was responsible for great advances in political life, mathematics, science, art, literature and, most importantly, philosophy. Most notable among all Greek philosophers were Plato and his teacher Socrates.

Plato and Socrates

It was the view of noted scholar Alfred North Whitehead that, 'All of [western] philosophy is but a footnote to Plato.' Some may disagree with Whitehead's assessment, but it would be hard to disagree with the view that Plato was the archetypal philosopher. He wrote on topics as diverse as justice, virtue, the nature of knowledge, love, beauty and the immortality of the soul. However, to view Plato and his teacher before him, Socrates, as merely great 'thinkers' is to perhaps superimpose our modern idea of what it means to be a philosopher.

Plato and Socrates were mystics and metaphysicians or doctors of the soul. Plato's philosophy was deeply spiritual and, like the great spiritual teachings before and after him, it was all about unity, the One, or what Plato called 'the Good'.

Plato, whose life span is estimated to be 428–348 BCE, was born of an aristocratic family in Athens. He was probably in his late teens when he met Socrates (469-399 BCE), who, by the standards of the day, was an old man.

It is said that Socrates had a dream one night that a magnificent swan alighted upon his lap and sang the most beautiful of songs.

When he met Plato, Socrates said he now knew the meaning of the dream and that Plato was that swan. Plato left a privileged life behind to follow Socrates and his method of pursuing the truth through the philosophical application of reason and questioning called dialectic. However, Socrates clearly asked too many questions of too many influential Athenians, who did not share the same love of truth, and so made many powerful enemies who eventually brought him to trial on trumped up charges. Even the threat of death could not shut him up and he was sentenced to death and subsequently executed at the age of 70. This deeply affected Plato. He left Athens and travelled widely for a number of years reaching Egypt, the Middle East and possibly even as far as India. Even if he didn't reach that far he certainly would have been exposed to a great number of Eastern spiritual teachings in his travels because ideas moved as freely along ancient trade routes as did the camels and donkeys carrying physical wares.

At approximately the age of 40 years of age Plato

returned to Athens and set up the prototype of the modern university in land alongside an olive grove called Academus. We derive our words 'academy' and 'academic' from that same grove. Plato taught until his death and The Academy had many well-known pupils, the most famous being Aristotle. During those years, Plato formulated and wrote down the key teachings he took from Socrates in what we now know as the Platonic dialogues, which are nearly all conversations between Socrates and notable Athenians of the day.

A major theme in Plato's dialogues is love. According to Plato, when we fall in love, true love, that is, and not just infatuation, we lose ourselves in the beloved. It is as if the ego dissolves and there is one connected being. *The Beloved is a Mirror* (opposite) uses the metaphor of a mirror to suggest that when we really connect with the beloved, particularly through the eyes as they are the windows to the soul, we really connect with ourselves. The two become one and we discover our own innermost self. We have to be still and present enough to see it, though. Such Platonic themes on love were a major source of inspiration during the Renaissance and in the centuries that followed.

If there were one phrase we associate with Greek philosophy it would have to be *Know Thyself.* It was inscribed above the entrance at the holy shrine at Delphi and was exhorted by Plato.

What does it mean to know oneself? Is there a self we think we are and another that we truly are?

The Beloved is a Mirror

According to many of the great wisdom traditions there is an ego (what we think we are) and an essential self (what we truly are). The one is a cluster of ideas we have identified ourselves with and the other is our being. One is of the mind and the other is beyond the mind. Such an inquiry can only really be explored through in-depth meditation or contemplation.

The calligraphic piece titled *Know Thyself* (p.98) provides two complementary quotes from Plato and Emerson. In the Platonic quote, Plato is in conversation with the talented but controversial

96

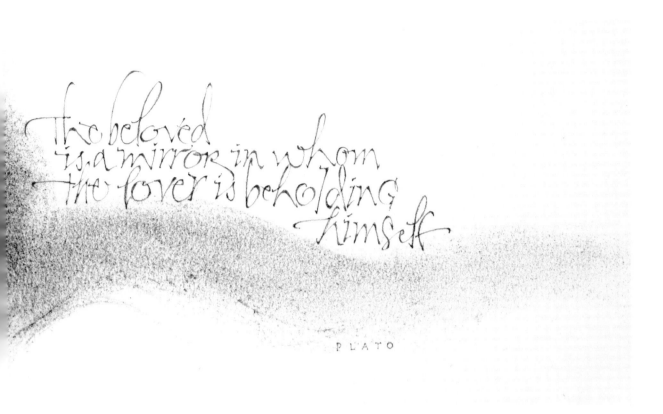

The beloved is a mirror in whom the lover is beholding himself

PLATO

general and playboy, Alcibiades. Alcibiades almost represents the internal struggle of all humans. He was drawn to Socrates' wisdom and virtue but also compulsively drawn to the pleasures of wealth, power and the body.

For Socrates and Plato, the inmost soul, the true self, is the seat of wisdom and as such most resembles God.

That is the self we should know, and should not be confused with the things that belong to it like the physical body, thoughts and physical possessions.

This divinity of the soul is also explored and described at length by Ralph Waldo Emerson, who was also much inspired by Plato. Emerson remarks that our divinity is hidden and unknown to most people, the mind being clouded by worldliness. It is like a veil over our eyes, preventing us from seeing the world and ourselves in their true light. As such we cannot hear or express our innate divinity, nor can we understand the laws of nature.

Know·Thyself

If thou can bear strong meat of simple truth... then tak[e]
this fact unto thy soul... God dwells in thee. It is no me[ta]
phor or parable, it is unknown to thousands and to th[ee]
yet, there is God. Then bear thyself O Man! Up to the
scale and compass of thy quest; Soul of thy Soul. Be gr[eat]
as doth beseem the ambassador who bears the roy[al]
presence where he goes. Give up to thy Soul... let it ha[ve]
its way... It is, I tell thee, God himself, the selfsame O[ne]
that rules the Whole, though he speaks through thee [with]
a stifled voice, and looks through thee shorn of his be[ams]
But if thou listen to his voice, if thou obey the royal
thought, it will grow clearer to thine ear, more glorio[us]
to thine eye. The clouds will burst that veil him now
and thou shalt see the Lord... This is the reason why t[hou]
dost recognize things now first revealed, because in the[e]
resides the Spirit that lives in all; and thou canst lear[n]
the laws of nature because its author is latent in thy br[east]

FROM GNOTHI SEAUTON BY RALPH WALDO EMERSON

Know Thyself
(see text on p. 96)

ΓΝΩΘΙ
ΣΕΑΥΤΟΝ

In ALCIBIADES I Plato comes to the essential point of the Delphic Maxim

CRATES THEN HE WHO ENJOINS A KNOWLEDGE OF ONESELF BIDS US
BECOME ACQUAINTED WITH THE SOUL. AND ANYBODY WHO
GETS TO KNOW SOMETHING BELONGING TO THE BODY KNOWS THE
THINGS THAT ARE HIS, BUT NOT HIMSELF. AND IF THE SOUL TOO IS
TO KNOW HERSELF, SHE MUST SURELY LOOK AT A SOUL, AND ESPECIALLY
AT THAT REGION OF IT WHICH OCCURS THE VIRTUE OF A SOUL WISDOM,
AND AT ANY OTHER PART OF A SOUL WHICH RESEMBLES THIS?
AND CAN WE FIND ANY PART OF THE SOUL THAT WE CAN CALL MORE
DIVINE THAN THIS, WHICH IS THE SEAT OF KNOWLEDGE?
BIADES WE CANNOT. SOC THEN THIS PART OF HER RESEMBLES GOD, AND
WHOEVER LOOKS AT THIS, AND COMES TO KNOW ALL THAT IS DIVINE,
WILL THEREBY GAIN THE BEST KNOWLEDGE OF HIMSELF ALC APPARENTLY.

Neo-Platonists

Neo-Platonism is a term given to philosophers and writers who were significantly influenced by Plato. It is often viewed as being more mystical and religious than the purely academic streams of Platonic thought. Neo-Platonism is generally thought to begin with Plotinus and end with the closing of the Platonic Academy by the Roman Emperor Justinian in 529. There was much debate in the early Christian Church about whether to follow Plato's mystical and deeply spiritual writings or Aristotle's more scholastic approach. The Church chose to follow Aristotle, largely influenced by St Augustine. Some say this was a philosophical wrong turn that has stayed with Christianity ever since.

Plotinus (204–270 BCE?) is considered to be the founder of Neo-Platonism. His writings are particularly noted for their mysticism. The recurring Platonic themes in Plotinus' writings are the intelligence imbued throughout the cosmos, and the divine nature of the soul. In *Being and Beauty* (opposite) Plotinus equates these two as one and the same. Thus our innate love and desire for beauty arises because our being is beautiful. Like is drawn to like.

The soul is beautiful when it acts in likeness with its own true nature and is deformed and ugly when it acts contrary to that nature.

Thus, if we don't know our true nature we are both ignorant and ugly.

Plato's writings on love, justice, virtue and beauty were a major source of inspiration for Renaissance art, philosophy and literature, particularly due to the translations and commentaries of Marsilio Ficino (1433–1499) from Florence. As a boy Ficino was supported and mentored by Cosimo de Medici, a founding member of the powerful family dynasty that ruled Florence. He later became a priest, philosopher, doctor and musician. He inspired many artists from Botticelli to Michelangelo, and writers from 15th century Florence through to Erasmus, Thomas More, John Colet and William Shakespeare. Cosimo employed Ficino as tutor to his grandson Lorenzo. Ficino passed on his teachings through convivial meetings held at his Platonic Academy in Florence and through his extensive correspondence. Light is a common metaphor used by Ficino to represent God and wisdom. In the *Ficino Letter* (p.102) they are one and the same. The vehicle of wisdom is the clear and lucid mind, just as a clear sky allows the rays of the sun to pass unimpeded. Serenity is the way to that clarity.

Being is desirable because it is identical with Beauty, and Beauty is loved because it is Being. We ourselves possess Beauty when we are true to our own being; ugliness is in going over to another order; knowing ourselves, we are beautiful; in self-ignorance, we are ugly.

—— PLOTINUS ——

Being and Beauty

MARSILIO FICINO
TO PHILOSOPHERS AND
TEACHERS OF SOPHISTRY

As the sky is to the light of the sun,
so is the mind to the light of truth & wisdom.
Neither the sky nor the intellect ever recieve
rays of light while they are clouded, but once
they are pure and clear they both receive them
immediately....The one way to that light for us
IS SERENITY.

Excerpt · VOL. 4, Letter 7

Ficino Letter (see text on p. 100)

To attain serenity we have to leave our preoccupations with and attachments to the worldly things that continually agitate the mind.

There was said to be an inscription around the walls of Ficino's Academy titled *Rejoice in the Present* (below). It is a simple exhortation to pursue virtues such as simplicity, humility, stillness and moderation. This is a path to find the goodness from which all things come and to which they return. If this goodness is to be found in virtue, it is also to be found in the present moment.

Rejoice in the Present

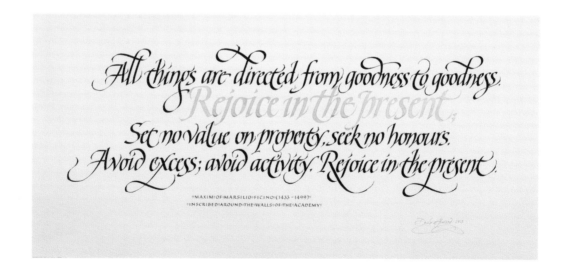

All things are directed from goodness to goodness.
Rejoice in the present;
Set no value on property, seek no honours.
Avoid excess; avoid activity. Rejoice in the present.

·MAXIM·OF·MARSILIO·FICINO·(1433–1499)·
·INSCRIBED·AROUND·THE·WALLS·OF·THE·ACADEMY·

Other classical philosophers

The Stoics were a school of philosophers known for their view that it was not what someone thought but what they did that determined a good person and a good life. Also important were having faith in natural law and a belief in the importance of self-control, the latter being what most people associate with the term stoic. Epictetus (55–135) was one of the most famous adherents of Stoicism along with Zeno, Seneca and Marcus Aurelius. *Nothing Great is Created Suddenly* (opposite) conveys the popular notion for the Stoics that all things have their natural time.

Just as a flower cannot bloom nor a fruit ripen before its time, so it is with the affairs of humankind.

Every endeavour begins as a seed of an idea which must take root, be nurtured, begin to flower and, eventually, bear fruit if the conditions are conducive. Impatience and not attending to the right to time and nurturing conditions is unnatural, wasteful and an exercise in futility.

Hermes Trismegistus, or 'thrice-great Hermes', is the supposed writer of the *Corpus Hermeticum*, a collection of sacred mystical texts treasured by the ancient Greeks and Egyptians. Not much is known about Hermes himself, who was said to have God-like qualities, but the Hermetic writings were greatly treasured by generations of later philosophers including Plato, the Neo-Platonists and Sufi writers. A number of Christian writers, including Augustine and Ficino, saw Hermes as a pagan prophet foretelling the coming of Christianity. *Plunge Into This Bowl* (p.107) represents plunging into the bowl of knowing or Nous.

It is in gaining wisdom that we realize the reason we came into being in the first place.

One of the recurrent themes of the classical period was beauty.

For the ancients, the closer one got to the transcendent reality, the One and Eternal Truth, the closer one got the essence of beauty itself.

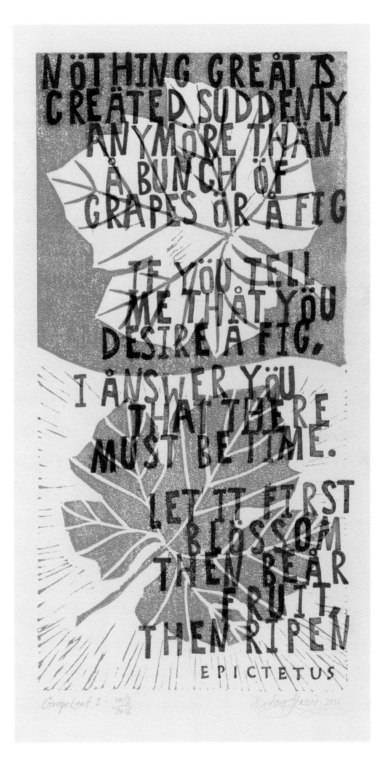

Nothing Great is
Created Suddenly

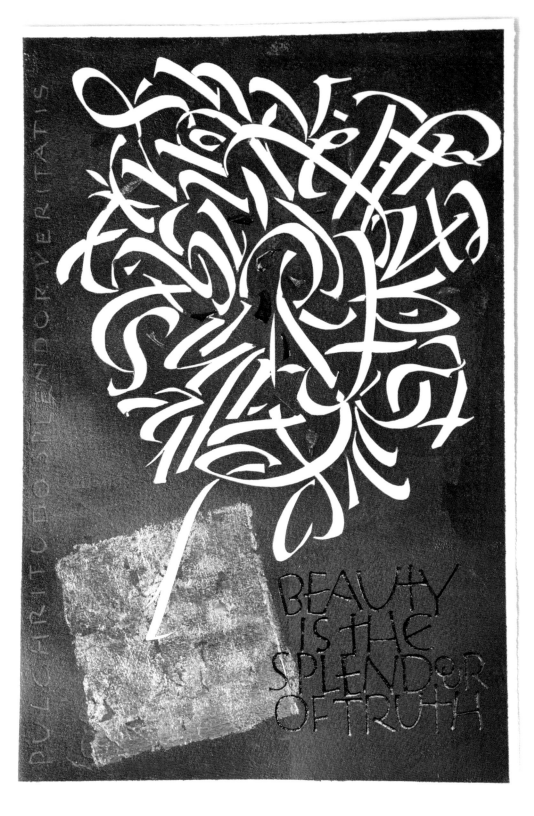

PULCHRITUDO SPLENDOR VERITATIS

BEAUTY IS THE SPLENDOR OF TRUTH

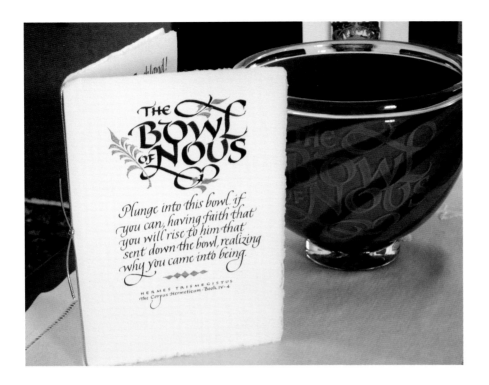

This was reflected in their mythology, art, architecture and literature. Thus truth and beauty were inseparable because they were one and the same, like the sun and its rays. Unlike relative things, absolute truth does not change with time, place or personal opinion.

We may be more or less ignorant of truth, but that has no effect on its nature, existence or expression.

Truth, being the most sacred, expresses itself, or makes itself known through the beautiful. Thus, beauty is the splendour of truth as seen in *Pulchritudo Splendor Veritatis* (opposite).

Plunge Into This Bowl
(see text on p. 104)

Opposite: Pulchritudo Splendor Veritatis

Literary figures

Dante degli Alighieri (1265–1321 BCE?), or simply Dante, is one of Florence's favourite sons. As a poet he is best known for his immortal masterpiece of literature, *Comedia*, later named *The Divine Comedy* by Boccaccio. The rich and graphic imagery in this epic poem has inspired many artists and writers within Italy and beyond her borders for centuries. ***Nature is the Art of God*** (p.110) is a simple depiction of God as an artist. We live within the warp and weft of God's natural canvas and, if we have eyes to see, we can be struck by beauty all around us. As adults our perception becomes somewhat dimmed with disinterest, distraction and familiarity, but to a child nature is fascinating, full of discovery and awe.

Generally it is only the child, or perhaps an adult like Einstein who looked at nature with the eyes of a child, who can really appreciate nature's masterpiece.

Virgil (70–19 BCE) was a Roman poet most noted for his epic mythical poem, *The Aeneid*. He was clearly well respected, for long after the passing of the Roman Empire he appears as Dante's guide through Hell and Purgatory in the *Divine Comedy*. Generally when we look at events, both natural and man-made, we have little understanding of their underlying causes. As such, if we make mistakes we are likely to repeat them, or if we wish to master something we will be unable to do it. ***Fortunate is He Who Understands the Causes of Things*** (p.111), for only a person who learns from their mistakes becomes

a master of self and circumstances, or comes to understand the workings of the universe.

The German Johann Wolfgang von Goethe (1749–1832) was something of an all-rounder. Not only was he a gifted writer, poet and novelist but he was also a statesman and scientist. He is revered by many other noted writers, including Arthur Schopenhauer and Ralph Waldo Emerson. Possibly his best-known work is the play *Faust*. As with just about every other writer and philosopher worth their salt, in ***Hold Always to the Present*** (p114) Goethe recognizes the importance of the present moment. What we are meeting now is the product of the past, and what we do now will frame what we meet in the future, but the only moment in which we can amend the mistakes and omissions of the past or lay the foundations for a better future is now.

William Shakespeare (1564–1616), affectionately known as the 'Bard', is the most respected dramatist of all time and probably the greatest writer in the English language.

He was born and raised in Stratford upon Avon and educated in the local grammar school, instigated under the liberal art-based educational philosophy developed by John Colet who, in turn, was influenced by Plato and Marsilio Ficino. Despite being so famous a playwright, little is known about Shakespeare the man. He left Stratford as a young man in 1585 shortly after his wife, Ann Hathaway,

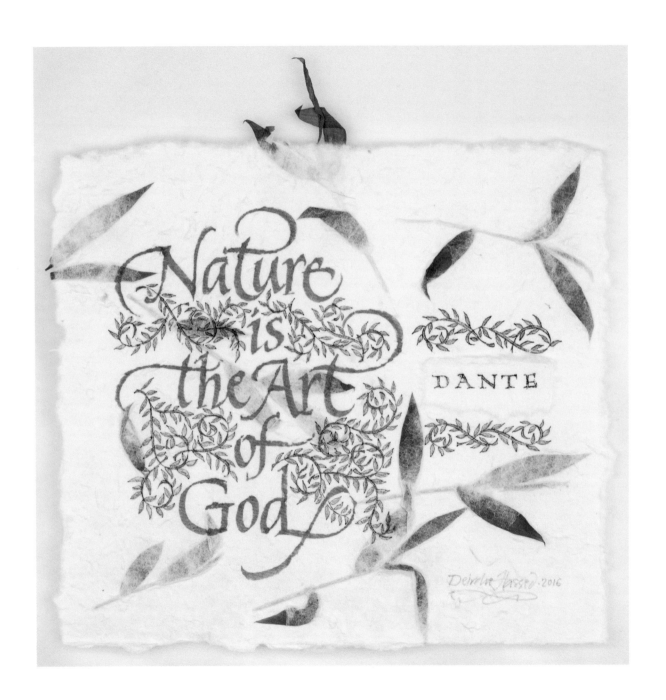

Nature is the Art of God

DANTE

felix qui
portuit
rerum
cognoscere
causas

Fortunate is he who understands
the causes of things.

VIRGIL

Fortunate is He Who Understands the Causes of Things (see text on p. 109)

Opposite: Nature is the Art of God (see text on p. 109)

gave birth to twins. It is not clear why he left, possibly because of trouble with the law for deer poaching or because, being Catholics, members of his family were being implicated by association with some central figures in a conspiracy against the Crown. He appeared in London's theatre scene in 1592 and little is known about 'the missing years' between 1585 and 1592 although one William Shakeshafte worked as a tutor in the household of the wealthy Catholic Jesuit Lancashire landowner Alexander Hoghton about the time that Shakespeare left Stratford and left the Hoghton household about the time that Shakespeare appeared in London. Inspired by the Renaissance, Hoghton is said to have had a remarkable collection of classic texts, which would no doubt have provided 'Shakeshafte' with access to a broad literary and philosophical education. If Shakeshafte and Shakespeare are one and the same, this may well explain why Shakespeare knew so much about so many places, as well as having such a deep spiritual and philosophical inspiration for his plays and sonnets.

Sonnet 15 (p.115) is an ode to the transience of mortal life and physical perfection. In fact, the whole physical world is merely a passing show. Everything that comes into being must grow, mature, decline and die. Time is the great companion, taking us on an inevitable journey from the day that is youth to the night that is death. On a superficial level the sonnets can be read as beautiful and romantic love poems and as such it is easy to engage in endless debate about who they were written for. All that is likely to be futile and missing

the point of the poem. Much like the Sufis,

Shakespeare's sonnets and plays are, at their heart, philosophical and spiritual. They point to the anxiety and grief that is inevitable when pinning our hopes on things that pass like physical health, wealth, pleasure and youth.

When, however, we graft ourselves to that which does not change within us, then we enjoy the passing pleasures of life but without the anxiety and grief that would otherwise come from illness, old age and death.

A similar theme of transience is communicated in this famous passage from Shakespeare's *The Tempest*, *We are Such Stuff as Dreams are Made On* (p.116). From a small view we think things are permanent but they are clearly not. Mighty towers, palaces and temples all come and go, so how much more temporal are we as characters in this play of life? If the view enlarges then we realize that even the Earth itself will come and pass. To Shakespeare, the whole universe is merely an insubstantial pageant and will come to nothing. The most crucial line comes at the end.

Our life is as substantial as a dream and we are as good as asleep, but what we are is what is underneath the dream.

We are the underlying consciousness, the being that the dreams are made *on*, not what the dreams are made *of*. That doesn't pass. It is awake. It is there

before the dream, during it, and after it has gone.

Every Shakespearean play is full of gems, and none more so than *Hamlet*. At one stage Prince Hamlet receives some sage advice from Polonius, **To Thine Own Self Be True** (p.117). What is the self that we are meant to be true to? Perhaps a hint is found later in the same play in the immortal line, 'To be or not to be, that is the question'.

Perhaps our true self is to be found in being, not in becoming.

Being is, becoming comes and goes. Being is conscious. What we are conscious of — that which is always becoming — comes and goes. Being is stable, like a rock. Becoming is here today and gone tomorrow, unstable like sand. The theme of being and becoming was a very strong one in Plato's dialogues, particularly *The Republic, Phaedo* and *Parmenides*. It naturally follows that if we can live our life from what is true within us then we will be authentic and truthful to others.

Sonnet 116 (p.118) is possibly one of Shakespeare's most famous. Truth does not change. On the other hand, things that are not true do change. Therefore, love that is not true is love of things that change and are not lasting, such as the body, youth, looks, wealth, opinions, approval, success or status. We may feel strong emotions and attachments while the conditions of our desire are satisfied, but once those conditions have changed then the love runs cold, or even turns to hostility. It is not true love.

In contrast, true love is love of that which does not change.

It is stable amidst change, even the tempestuous ups and downs of life, like sickness and death. It is beyond time, looks or any other superficial thing. It is of the inmost soul. Shakespeare is clearly making an emphatic and confident statement in this sonnet when he ends with the line, 'If this be error and upon me proved, I never writ, nor no man ever loved'.

One of the most enigmatic authors and artists in English history is William Blake (1757–1827). He lived in London but was not well known or widely read in his day. Perhaps a little too idiosyncratic for that period, he was way ahead of his time with his evocative images and devotional writing rich in symbolism. One of his most respected projects, unfortunately incomplete because of his death, was to illustrate Dante's *Divine Comedy*. During his lifetime Blake was controversial for his criticisms of conventional religion but was himself a deeply spiritual man and even wrote his own mythological stories and characters.

In the quote, *Eternity's Sunrise* (p.120), Blake conveys an important message about living life fully but without attachment. Like a bird in flight, pleasure and pain come and go. When, through attachment and desire, we attempt to 'bend' or manipulate things to suit ourselves, we destroy them, or at least the joy that comes with them. It is like attempting to put the bird in a cage. Blake advises that we should kiss the joy as it flies.

Hold Always to the Present (see text on p. 109)

When I consider everything that grows
Holds in perfection but a little moment,
That this huge stage presenteth nought but shows
Whereon the stars in secret influence comment;
When I perceive that men as plants increase,
Cheer'd and check'd even by the self-same sky,
Vaunt in their youthful sap, at height decrease
And wear their brave state out of memory;
Then the conceit of this inconstant stay
Sets you most rich in youth before my sight,
Where wasteful Time debateth with Decay
To change your day of youth to sullied night;

And all in war with Time for love of you,
As he takes from you, I engraft you new.

SONNET XV · WILLIAM SHAKESPEARE

Sonnet 15 (see text on p. 112)

Our revels now are ended.
These our actors, as I foretold you,
Were all spirits and are melted into air,
Into thin air: And, like the baseless fabric
Of this vision, the cloud-capp'd towers,
The gorgeous palaces, the solemn temples,
The great globe itself, yea all which it inherit,
Shall dissolve and like this
Insubstantial pageant faded, leave not
A rack behind. We are such stuff
As dreams are made on, and our little life
Is rounded with a sleep.

WILLIAM SHAKESPEARE

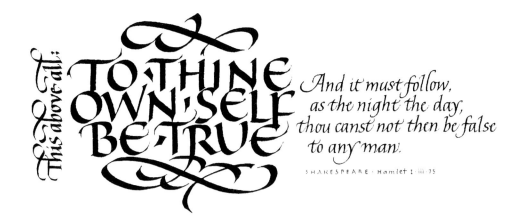

This above all:
TO THINE OWN SELF BE TRUE
And it must follow, as the night the day, thou canst not then be false to any man.

SHAKESPEARE · Hamlet I·iii·75

To Thine Own Self Be True (see text on p. 113)

Opposite: We Are Such Stuff as Dreams are Made On (see text on p. 112)

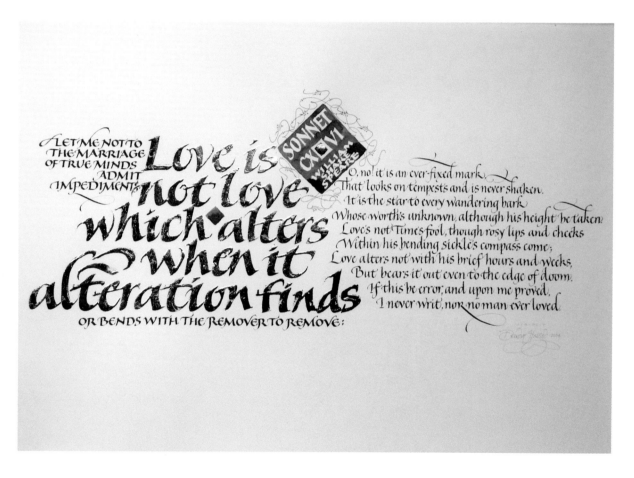

LET ME NOT TO THE MARRIAGE OF TRUE MINDS ADMIT IMPEDIMENTS. **Love is not love which alters when it alteration finds** OR BENDS WITH THE REMOVER TO REMOVE:

SONNET CXLVI WILLIAM SHAKESPEARE

O, no! it is an ever-fixed mark,
That looks on tempests and is never shaken.
It is the star to every wandering bark
Whose worth's unknown, although his height be taken.
Love's not Time's fool, though rosy lips and cheeks
Within his bending sickle's compass come;
Love alters not with his brief hours and weeks,
But bears it out even to the edge of doom.
If this be error, and upon me proved,
I never writ, nor no man ever loved.

Sonnet 116 (see text on p. 113)

Following page: Eternity's Sunrise (see text on p. 113)

His quote evokes a sense of living life with a light touch; just being in the present moment and enjoying things as they are but also being able to let them pass without trying to possess them.

If we can do that then we live in 'eternity's sunrise', an image which conjures a sense of ongoing bliss, free of the anxiety and grief that comes with trying to hold onto the transient and mourning when it inevitably passes.

Francis C Roles (1901–1982) was a doctor but was better known as a philosopher. He was originally inspired by Pyotr Demianovich Ouspensky, a Russian mathematician, and by Ouspensky's teacher, the Greek-Armenian George Gurdgieff. However, he later adopted the teachings of Shantananda Saraswati, who was a teacher in the Indian philosophical tradition set up by Shankara many centuries before. Dr Roles was instrumental in giving impetus to the popularization of meditation in the early 1960s through Maharishi Mahesh Yogi.

In 1951 Dr Roles set up the Study Society, which examined the world's great spiritual traditions and explored how that wisdom might be expressed morally and artistically for the wellbeing of society. *Art is Love in Action* (p.122) speaks to the creative urge within us all that is too often latent.

Art has the potential to be an expression of what we love, what we hold most dear.

There is something deeply satisfying about giving expression to that creative urge and we each do that in our own unique way. One might even go so far as to say it is a human need.

Boston is known as the world's leading city of learning and it has a rich literary and philosophical tradition, as well as being home to many of the most important events in US history. Among the greatest of American intellectuals from Boston was essayist, poet, lecturer and philosopher Ralph Waldo Emerson (1803–1882) who led the Transcendentalist movement in the mid 19th century. The Transcendentalists were a literary, philosophical and political movement concerned with a number of issues including anti-slavery and women's rights. Oliver Wendell Holmes commented that Emerson's 1837 speech titled 'The American Scholar' was America's 'Declaration of Independence'. Emerson was of the view that God could be experienced directly through nature and spoke to us with the 'still, quiet voice' of intuition or conscience. Emerson's quote, *The All is in Each Particle* (p.123), raises the paradox about how something so small can express something so infinitely large. It clearly doesn't make sense unless one considers that universal laws express themselves everywhere, all of the time.

If we understand all that goes on in a particle then we may well have insight into the universe, for it is simply the particle writ large.

He who bends to himself a joy doth the winged life destroy;

BUT HE WHO KISSES THE JOY AS IT FLIES LIVES IN ETERNITY'S SUN-RISE.

WILLIAM BLAKE

Denis Glasser 2008

everyone at sometime wants to create
something original, something of their own.
We all have innate in us some special
aptitude of self-expression, something
each of us could do and a way to do it
which is entirely our own. To find it, & use it
gives self-realization its full meaning.

FRANCIS C. ROLES

The All is in Each Particle

RALPH WALDO EMERSON

The All is in Each Particle
(see text on p. 119)

Opposite: Art is Love in
Action (see text on p. 119)

Deirdre Hassed 2008

One striking thing about people of the stature of Emerson is that they have the confidence and clarity to live an authentic life, true to themselves and their values. They are not easily diverted from what they are committed to. **The Greatest Accomplishment** (p.126), according to Emerson, is to live such an authentic life. There are so many things to distract us, tempt us, corrupt us and confuse us, that few people escape such worldly influences unscathed.

One good indicator of when we are living authentically is that we feel at peace with ourselves.

A close friend and colleague of Emerson's was Henry David Thoreau (1817–1862). He was born in Concord, outside of Boston where Emerson spent much of his later life. Thoreau was also a philosopher of the Transcendentalist stamp, a lover of nature, a poet and writer. Both Emerson and Thoreau were abolitionists but Thoreau was far more politically disposed. His writings on civil disobedience, for example, influenced many including Mahatma Gandhi and Martin Luther King.

Expressing his wish to live as simply and directly connected with nature as he could, Thoreau went into the woods to live in isolation in a small cabin next to a lake by the name of Walden.

There he wrote his most famous work, *Walden*, which recounts this secluded life. He wanted to learn to live from nature, from necessity and from his own resourcefulness. Socrates famously said that 'an unexamined life is not worth living'. In no way was Thoreau going to be guilty of having a life without examination.

In **The Mental Path** (p.127) Thoreau pre-empts what modern neuroscience likes to call neuroplasticity. The metaphor of the path is a good one. By going over a piece of ground again and again we create a path, which makes it easier to go that way and harder to go another way. Similarly, when we think the same thoughts over and over again, in an undiscerning and unconscious way, the thoughts can become deeply etched ruts in our thinking, making it difficult to think or act differently.

We need to carefully choose the thoughts we wish to live by and make a conscious and consistent decision to reinforce them until they become the rules of our words and actions.

Baruch Spinoza (1632–1677) was a widely admired Dutch philosopher with Portuguese and Jewish heritage. He is well known for his work in opposing the mind–body dualism made popular by Descartes. Spinoza's most famous work *Ethics* was particularly influential in gaining his prominent place in Western philosophy.

To Spinoza, God was universal, impersonal, the ultimate substance beyond all other substances.

As such, God and nature were one and the same. As humans, while we believe we have free will, this is only because we have just enough awareness to recognize conscious desires but not enough light to illuminate our unconscious ones so as to determine that we are truly acting freely. ***Peace is Not an Absence of War*** (p.128) might only be a suppression of conflict and not real peace at all. Peace is really an inner mental state, one of virtue and from which we can care for others and act in a just way. It implies that a soul not at peace cannot really act virtuously or with clarity.

If we do act virtuously, whether as an individual or a society, then it is only by a socially imposed virtue that would be quickly forgotten if social constraints were removed.

T.S. Eliot (1888–1965) was born in the United States and later moved to England at the age of 25. He was a poet, essayist, playwright and literary critic and won the Nobel Prize for Literature in 1948. In his early life, Eliot was influenced by many authors including the great American, Mark Twain, and later by Dante and the Sufi poetic tradition among others. His poems, such as the famous 'Four Quartets', were highly symbolic and full of allegorical, spiritual and philosophical meaning. These famous lines from Eliot in the piece *We Shall Not Cease from Exploration* convey a theme common to many ancient mythologies as well as modern stories: the explorer's or hero's journey far from home and then back again. Along the way they encounter every kind of trial but come out stronger, wiser and more resilient. When they arrive home they are not the same, and they know and appreciate home in an entirely different way to when they left.

This journey is also a metaphor for life and our inner journey. We begin life in our innocence, we become lost and alienated from our self, we experience trials and hopefully learn from them, and then, if we are lucky, we find our way back to unity and inner peace.

To be yourself in a world
that is constantly
trying to make
you something else
is the greatest
accomplishment.

RALPH WALDO EMERSON

The Greatest Accomplishment (see text on p. 124)

126

*As a single footstep will not make
a path on the earth, so a single thought
will not make a pathway in the mind.
To make a deep physical path, we walk
again and again. To make a deep mental
path, we must think over and over the kind
of thoughts we wish to dominate our lives.*

THOREAU

The Mental Path (see text on p. 124)

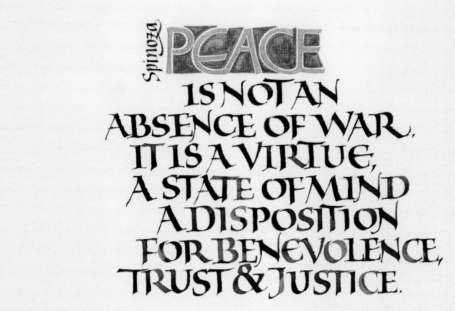

Peace is Not an Absence of War (see text on p. 125)

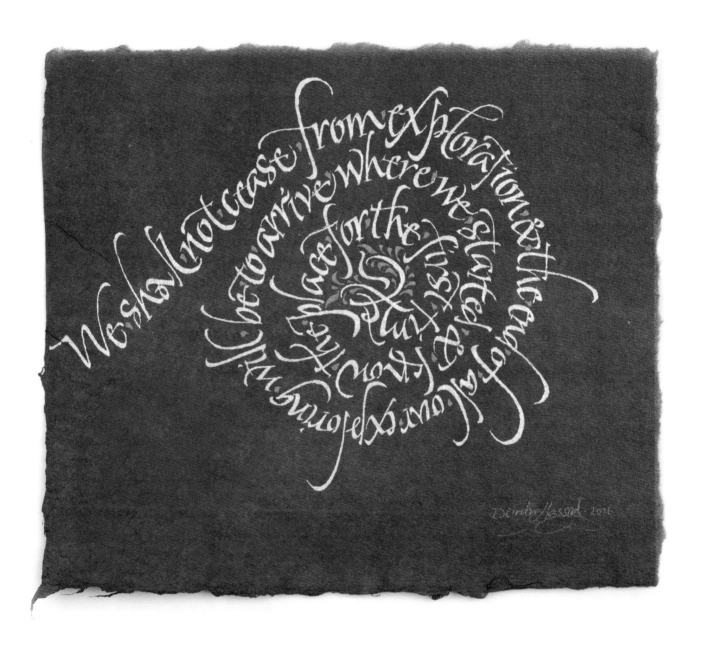

We Shall Not Cease from Exploration (see text on p. 125)

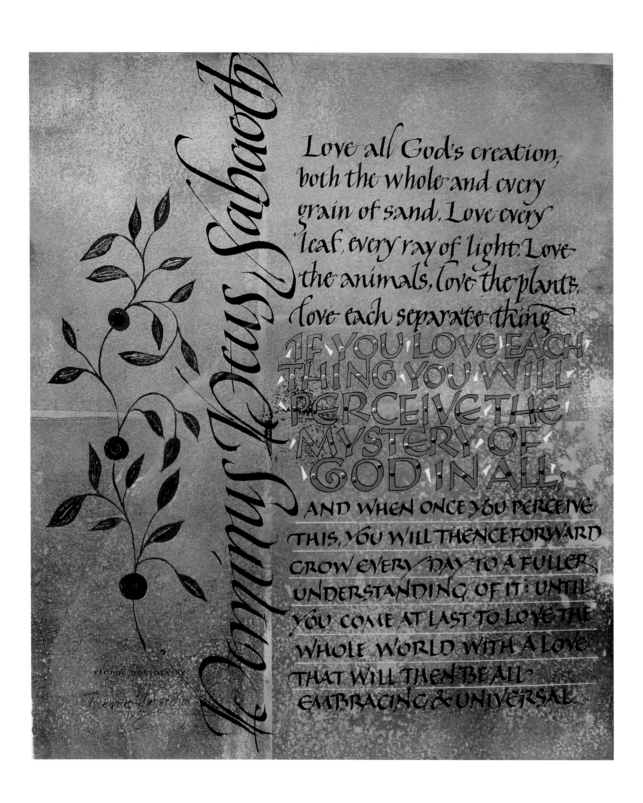

Love all God's creation,
both the whole and every
grain of sand. Love every
leaf, every ray of light. Love
the animals, love the plants,
love each separate thing.
IF YOU LOVE EACH
THING YOU WILL
PERCEIVE THE
MYSTERY OF
GOD IN ALL,
AND WHEN ONCE YOU PERCEIVE
THIS, YOU WILL THENCEFORWARD
GROW EVERY DAY TO A FULLER
UNDERSTANDING OF IT: UNTIL
YOU COME AT LAST TO LOVE THE
WHOLE WORLD WITH A LOVE
THAT WILL THEN BE ALL-
EMBRACING & UNIVERSAL

FEODOR DOSTOEVSKY

Sanctus Deus Sabaoth

Fyodor Dostoyevsky (1821–1881) was a Russian writer and philosopher who drew heavily on spiritual themes in his writings.

Although not particularly interested in formal religion, he was a deeply devotional man and found a deep connection with spirituality, especially through nature and contemplating the stars.

He also led a life that had its fair share of adversity. In 1849 he was exiled to Siberia for five years for reading banned literature. Afterwards he travelled through Europe and eventually returned to Russia in 1871. The message of the quote *Love all God's Creation* (opposite) is a simple one of expanding from the limited confines of individuality to universality through the transforming effect of love. In the process we discover we are a part of everything and everything is a part of us. In other wisdom traditions there are analogies used to illustrate this, such as a pot containing water and being broken apart so that the water returns to the river or ocean. The pot is the like the individual ego, which makes separation, rather than unity, seem like the reality.

Opposite: Love all God's Creation

Science

I do not know what I may appear to the world,
but to myself I seem to have been only like a boy
playing on the seashore, and diverting myself
in now and then finding a smoother pebble
or prettier shell than ordinary,
whilst the great ocean of truth
lay all undiscovered before me

ISAAC NEWTON

Truly great scientists and philosophers don't argue so much as share similar insights and say similar things in different ways. They are merely looking at the same phenomena from different perspectives. Mediocre theologians and scientists, on the other hand, have much to argue about. An example of this includes the uninformed dogma of the Catholic Church during the Renaissance coming into conflict with Galileo and new astronomical insights. Such conflicts between religion and science cause much harm and create huge schisms that are still being felt today. In the modern day, we have an emerging scientifically-founded and aggressive form of atheism, which is becoming increasingly intolerant of all things spiritual, dismissing it all as mere superstition.

One other striking thing about truly great scientists is their humility — they tend not to be overly impressed by their own intelligence and contemptuous of the intelligence imbued in nature.

Four examples of great scientists will be given from different periods in history.

Isaac Newton (1642–1727) was an English physicist and mathematician educated at Cambridge University. He was the main instigator of the modern scientific age. His discoveries in physics stood the scrutiny of centuries and even now are not refuted but merely refined according to new scientific insights. Newton would have been

Now is the Time to Understand

*Previous page: A Boy
Playing on the Seashore*

considered a religious man, although many of his thoughts on religion would have deviated from the church doctrine of the day, and so he largely kept them to himself. Newton, seeing himself as ***A Boy Playing on the Seashore*** (p.133), creates a beautiful image of a child full of wonder but also of awe at the undiscovered 'vast ocean of truth' lying before him. His description of his discoveries, which we view as momentous, as just finding a smooth pebble or a pretty shell on the seashore suggests he was conscious of the vastness and intelligence in nature. He was in awe of nature, not himself.

The first woman to win a Nobel Prize was Marie Curie (1867–1934). She actually won more than one. Her first Nobel prize was in Physics in 1903 and her second in Chemistry in 1911. She was born Maria Salomea Skłodowska in Warsaw, Poland, and became a naturalized French woman after marrying her equally famous scientist husband Pierre Curie. Marie had a long and successful career at the University of Paris but, not realizing the danger of the elements she was investigating, she died from a blood disease brought on by long-term exposure to radium and X-rays. Marie Curie had an incredibly curious mind. ***Now is the Time to Understand*** (opposite) describes the relationship between fear and understanding.

Nothing in life
is to be feared,
it is only to be
understood.
Now is the time
to understand more,
so that we may
fear less.

MARIE CURIE

Deirdre Hassed 2016

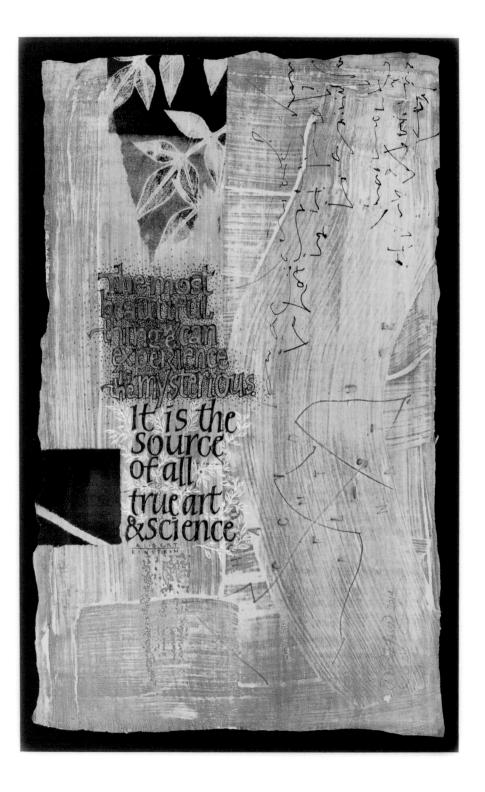

Everyone who is seriously involved in the pursuit of science becomes convinced that *a spirit is manifest in the laws of the universe* a spirit vastly superior to that of man, and one in the face of which we with our modest powers must feel humble. In this way the pursuit of science leads to a religious feeling of a special sort, which is indeed quite different from the religiosity of someone more naive

ALBERT EINSTEIN

A Religious Feeling (see text on p. 138)

Opposite: The Mysterious (see text on p. 138)

Statesmen and women

Marcus Cicero (106–43 BCE) was a Roman politician, political theorist, orator, writer and philosopher. Cicero was certainly a famous and important man in his day but there was a revival of interest in his writings during the Renaissance through the classical author Petrach. Later, Cicero's writings had a significant influence on prominent thinkers in the 18th century such as John Locke and David Hume. Cicero became implicated in various intrigues in the unsettled years during and following the rule of Julius Caesar. After Caesar's death Cicero fell out with Marc Antony and spoke against his policies. He was subsequently executed. ***Each Man's Mind is the Man Himself*** (opposite) says something important about Cicero's view of the human being. It is the mind, populated as it is by thoughts, emotions, ambitions, desires and the rest, that determines our words and actions. What we are on a physical level is merely a product of that mind. Doubtless, many wisdom traditions would remind Cicero that yes, the mind does define the creature, but what is beyond the mind? That is the true self and we experience that when we simply stand back from the mind and observe it in an impartial manner.

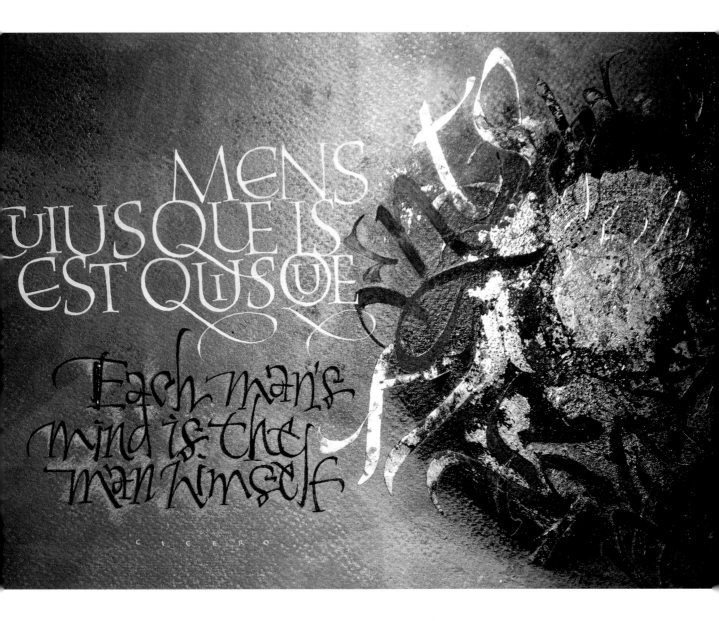

MENS
UIUSQUE IS
EST QUISQE

Each man's
mind is the
man himself

Each Man's Mind is the Man Himself

143

The office of President is looked upon with great respect and awe in the United States, and there are very few Presidents looked upon with more respect and awe than Abraham Lincoln (1809–1865). Largely a self-made and self-educated man, Lincoln was a lawyer before entering state and then federal parliament and becoming a prominent leader in the fledgling Republican Party. His views against slavery were well known, so when he was elected President in 1860 it was largely on the back of support from the northern states. The US soon fractured along north–south lines and the bitter and bloody American Civil War ensued. Lincoln was able to steer the US back to unification and away from slavery.

Lincoln gave one of the most famous and iconic speeches in history, the Gettysburg Address, which championed a democracy based on equal rights and liberty.

Tragically he was assassinated in 1865. Lincoln was a very humble and thoughtful man of great wisdom. Like others before and since, he recognized that it is not only adversity or pain that tests us, but also how we handle pleasure and power. The former can turn a person away from the right path through fear and aversion. In *To Test a Man's Character* (p.146), Lincoln was clearly also aware of the potential for power or pleasure to corrupt by seducing a person. By any measure, Lincoln lived up to this motto and, like many great leaders, demonstrated that it is not the love of power that is the driving force, but a great calling.

One notable thing about great leaders is that they know freedom is much less an outer state than it is an inner one. Mahatma Gandhi (1869–1948) taught this and other truths by the example he set. As he famously said, *You Must Be the Change You Wish to See in the World* (p.147). Gandhi was born and raised in Western India in a merchant family and went to London to study law. He later travelled to South Africa where he became involved in the movement for equality and civil rights for coloured races. Gandhi had to endure harsh treatment and periods in prison, but this only strengthened his resolve. He later moved back to India where he became the central figure in the non-violent struggle for rights and Indian independence. Mahatma, meaning 'great soul', was given to him in recognition of his outstanding qualities as a leader. His desire to create an India based on tolerance and religious pluralism caused anger among those with separatist ideologies and he was assassinated in 1948, soon after independence was achieved.

For a great soul such as Gandhi, there is no duplicity between thought, word and action. There is only consistency between what is thought, said and done. It not only helps us act with integrity but allows us to find peace within ourselves and for other people to trust us. It keeps life simple, whereas dishonesty and duplicity make it infinitely complex. As a deeply spiritual man Gandhi was much disposed to forgiveness and compassion.

Harming others, even in avenging a wrong, was always a lesser path than serving, uplifting and educating them.

According to Gandhi, the thing that stands in the way of experiencing compassion and service is largely our own sense of separation. To serve others wholly is a way to transcend our own self-centredness and liberate ourselves. In doing so we find our true self and leave our false self, the ego.

Winston Churchill (1874–1965) is one of the most outstanding figures of the 20th century. He grew up in an aristocratic English family with famous ancestors like the Duke of Marlborough. But he also had a variety of challenges, not least of which were a distant relationship with his parents and poor academic performance at Harrow and later at Sandhurst Royal Military College.

However, Churchill seemed to have a knack of turning adversity to advantage and learned much about independence, perseverance and resourcefulness as he grew up.

His life was certainly colourful. He worked as a war correspondent in the Boer War, got captured and sensationally escaped, served bravely in the army, entered parliament, got elected and then lost his seat, got elected again, and then, as First Lord of the Admiralty, oversaw both successful and unsuccessful campaigns in World War I. Other remarkable aspects of his life were his prolific writing, particularly about history, for which he won a Nobel Prize for Literature in 1953. He was also famous for his artwork, bricklaying, wit, having depression (for which he famously coined the phrase 'the Black Dog') and his oratory skills. He was noted for his courage and indomitable spirit which, in accordance with his sense of destiny, came to the fore as the Prime Minister in World War II against Nazi Germany. He described England as a lion; he just gave it 'the roar'. These short quotes (p.146) are an example of Churchill's ability to say insightful and colourful things in few words. He would not have been the man he was without the ability to learn from failure, to maintain determination in adversity, and without his dedication to giving to others through public service. He was a truly remarkable man.

Eleanor Roosevelt (1884–1962) experienced much grief in early life with the death of both her parents and a brother while she was still very young. Rather than breaking her, these experiences helped Eleanor grow in strength and self-reliance. She married Franklin D Roosevelt in 1905 but was fiercely determined to have her own public life and so dedicated herself to a variety of issues, including the rights of women, racial minority groups and refugees. When her husband was elected President in 1933 she became a powerful advocate for a range of social issues. Her abilities and passion were widely sought and after the death of her husband she became the United States Delegate to the United Nations General Assembly from 1945 to 1952, was the first

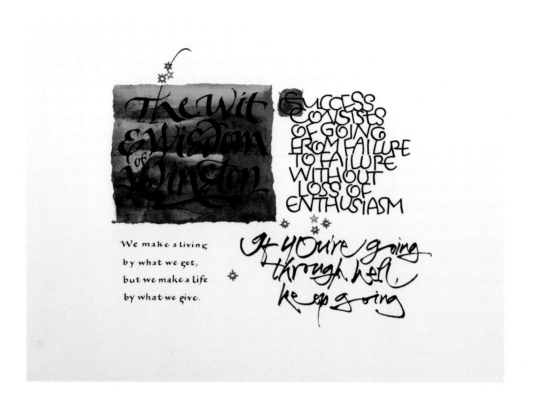

The Wit and Wisdom of Winston
(see text on p. 145)

Nearly all men can stand adversity, but if you want to test a man's character, give him power

LINCOLN

To Test a Man's Character
(see text on p. 144)

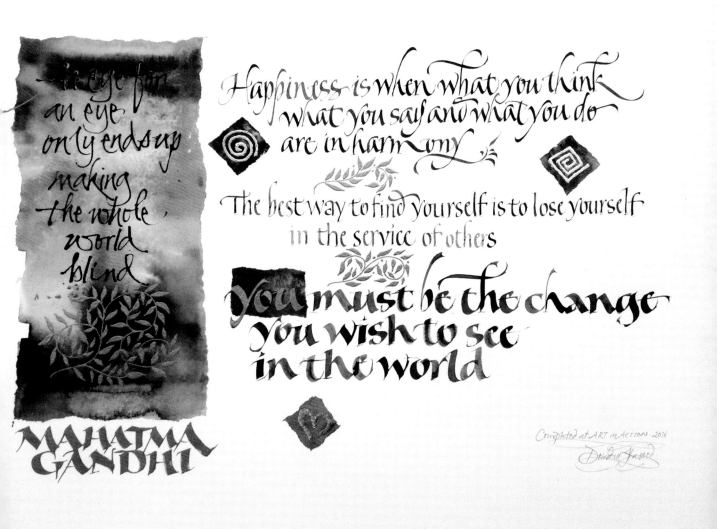

You Must Be the Change You Wish to See in the World
(see text on p. 144)

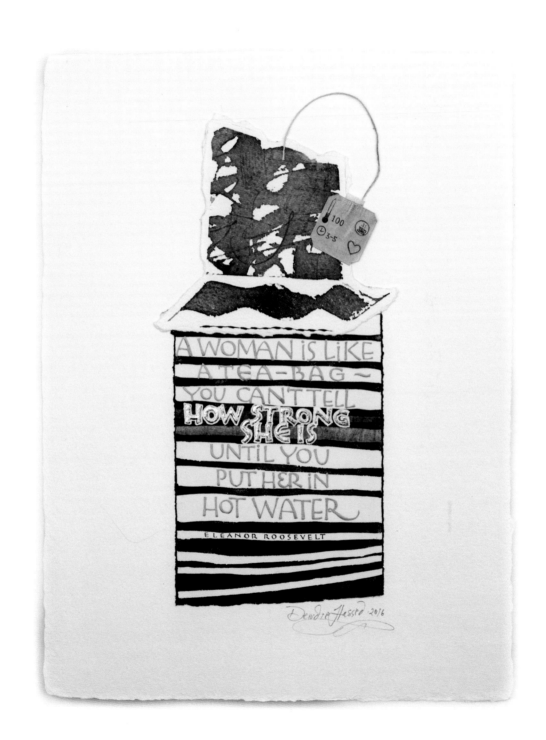

A WOMAN IS LIKE
A TEA-BAG ~
YOU CAN'T TELL
HOW STRONG
SHE IS
UNTIL YOU
PUT HER IN
HOT WATER

ELEANOR ROOSEVELT

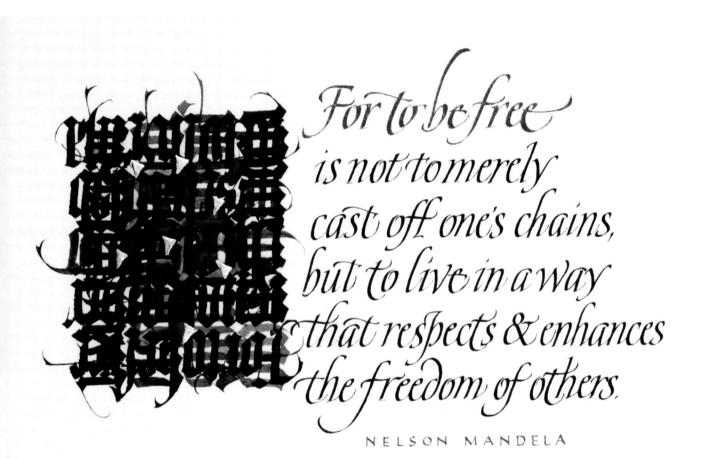

For to be free
is not to merely
cast off one's chains,
but to live in a way
that respects & enhances
the freedom of others.

NELSON MANDELA

To Be Free (*see text on p. 150*)

Opposite: A Woman is Like a Teabag (*see text on p. 150*)

chair of the UN Commission on Human Rights, oversaw the drafting of the Universal Declaration of Human Rights and chaired John F Kennedy's Presidential Commission on the Status of Women. If anybody should know anything about resilience and the potential of women then it should be Eleanor Roosevelt: she clearly knew that it is only in times of adversity that a person is really tested and then has the opportunity to discover their real strength. *A Woman is Like a Teabag* (p.148) is an apt and memorable metaphor to remind us of the fact that our real potential tends to remain hidden to us unless something draws it out.

It is almost inconceivable that a person should be sent to a brutal prison merely for standing up for justice, serve 27 years of hard labour, and then re-emerge with a heart full of compassion even for his jailers, a mind set on justice for all, and a readiness to spend the rest of his life in public service. Such a man was Nelson Mandela (1918–2013). Born in South Africa's Cape Province, he grew up in a village and worked hard to become a lawyer. As a black man in South Africa he experienced first-hand the institutionalized racism of apartheid. He found himself being drawn down a path of activism and resistance that soon brought him into conflict with the authorities. In a heavily publicized trial in 1962, Nelson Mandela and his colleagues were eventually sentenced to life imprisonment in 1964.

No doubt the authorities thought that would be the end of him but Mandela, or 'Madiba' as he would later be called, became the figurehead for the growing

How to Think About Politics
(*see text on p. 153*)

national and international pressure to end apartheid. His imprisonment became the symbol of the peaceful struggle for liberation. He was eventually released in 1990 and then elected as the president of the African National Congress. Later, in the first free election in South Africa's history in 1994, he became the President. He then oversaw the peaceful transition to post-apartheid South Africa and became a symbol of peace, freedom and reconciliation around the world.

To Be Free (p.149) sums up just a little of what it takes to be a person of universal vision and great wisdom. A person of limited vision may want freedom, justice, rights or compassion for their family or friends, or members of the same race or religion.

But a person of great heart and wisdom appreciates the universal nature and value of freedom, justice, rights and compassion and therefore wants them for all, not just those who they might feel partial to.

Great statesmen are able to transcend individuality and live universally.

In more recent times the role of women has

This is the way I was brought up to think of politics, that politics is to do with ethics, it was to do with responsibility, its to do with service, so I think I was conditired to think like that, & I'm too old to change now.

AUNG SUN SUU KYI

The Dalai Lama, when asked what
surprised him most about humanity,
answered "Man... Because he sacrifices
his health in order to make money.
Then he sacrifices money to recuperate
his health. And then he is so anxious
about the future that he does not
enjoy the present; the result being that
he does not live in the present or the future;
he lives as if he is never going to die,
and then dies having never really lived.

SCRIPSIT
Deirdre Hassed · 2016

shifted significantly around the world. This has allowed women to play a more prominent role in politics. One such inspirational woman is Aung Sun Suu Kyi (1945–). Suu Kyi grew up in Burma and then India with her diplomat–politician mother. Her father had been prominent in negotiating the independence of Burma from the British but he was assassinated when Suu Kyi was young. Suu Kyi was later educated at Oxford in philosophy, politics and economics before moving to New York where she worked for a time at the UN. She married and started a family but eventually moved back to Burma in 1988. Her return corresponded with the rise of a democracy movement and she stood for election as President in 1990. Although her party won, the military junta in control at the time wouldn't cede power and placed her under house arrest instead.

Like Nelson Mandela, Aung Sun Suu Kyi's imprisonment represented the peaceful fight for freedom and democracy and in 1991 she was awarded the Nobel Peace Prize for her efforts.

She was placed under house arrest periodically until eventually being released for the last time in

2010. In 2015 her party finally won a fair general election under her leadership. Although she was barred from taking up the presidency, she does occupy a number of senior ministerial positions. Like other inspirational leaders, Suu Kyi expresses her view of leadership in **How to Think About Politics** (p.151). It is not the personal ambition of the politician that should be the motivation behind taking office, but a duty to shoulder responsibility, to serve, and to do so ethically. Clearly her parents and spiritual upbringing in Buddhism and Christianity had a significant influence on her views of political leadership, which accord well with Plato's thoughts on what should motivate a leader.

If there was any good to come out of the invasion of Tibet by China then it must have been that a man of the stature of the Dalai Lama was driven into the world's spotlight. Born Tenzin Gyatso in 1935, he was chosen as a young child to become the 14th and current Dalai Lama in the Gelug school of Buddhism. With tensions escalating between Tibet and China throughout the 1950s, the Dalai Lama fled to northern India in 1959 and set up a government in exile, where he has remained ever since. As a result of championing the cause of the Tibetan people, the Dalai Lama has been welcomed by many world leaders and has been able to spread his message of tolerance, non-violence, compassion, humility and the need for a universal form of spirituality and morality.

Today Buddhism is a far better known and respected religion because of his influence. The Dalai Lama is also known for his sense of humour

and simplicity in teaching, which is indicated by this quote, **What Surprises Me Most About Humanity** (p.152). He really highlights the paradoxes that abound in our restless and oftentimes misguided search for happiness, health and a future that never comes. If we search for such things without wisdom then we may look in the wrong places and find the opposite of what we seek.

> **This distracted existence, in ignorance of our inevitable mortality, means we never really look deeper or seek a more truthful meaning to our lives.**

It echoes Socrates' words, 'The unexamined life is not worth living'.

True courage is an uncommon commodity, but to find it in such a young person is indeed rare. Malala Yousafzai (1997–) is such a person. She was born and raised in the Swat Valley in Pakistan. Her father, as an educationalist passed on his passion for education, especially women, to his daughter. Malala rose to prominence at the age of 12 when she wrote a blog for BBC Urdu about her life under the Taliban. Subsequently a *New York Times* documentary was made about her life and the causes she was championing. This raised the ire of the extremists in her region and in 2012 an attempt was made on her life while she was travelling on her school bus. Although the bullets were fired at close range into her head, incredibly she was not killed. Malala was flown to Birmingham where she had intensive care and made a remarkable recovery. Undaunted by the attack, Malala has continued to champion the cause of female education with even more passion and courage than before. Her work culminated in her winning the 2014 Nobel Peace Prize, becoming its youngest ever recipient. In this quote, **Strength, Power and Courage Were Born** (opposite), Malala indicates the response of a person with real conviction and courage when faced with ignorance.

> **Adversity and fear do not destroy or deflect such a person, they merely try them in a fire that makes them stronger than before. Malala's power stems not from a position of political influence or the barrel of a gun, but from the moral force of her undertaking and the purity of her heart.**

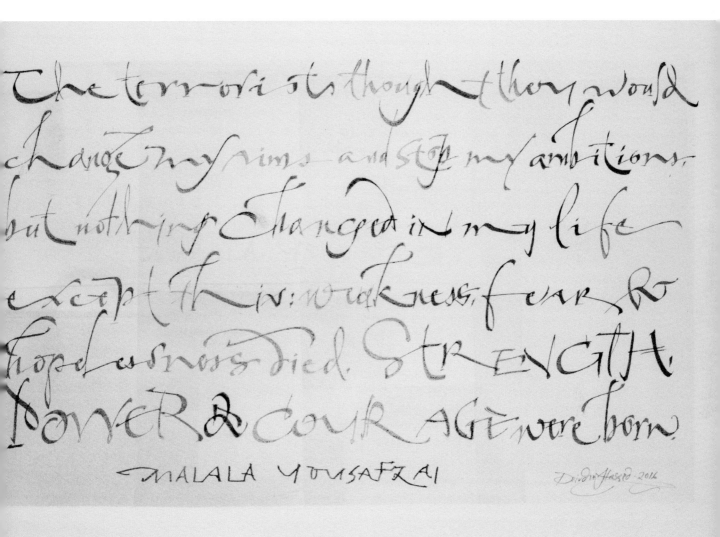

The terrorists thought they would change my aims and stop my ambitions, but nothing changed in my life except this: weakness, fear & hopelessness died. STRENGTH, POWER & COURAGE were born.
—MALALA YOUSAFZAI

Strength, Power and Courage Were Born

155

Artist's notes

Page 11: *Illuminate* Collage of monoprints on Japanese paper, cut letters and foil on BFK Rives paper

Page 15: *Listen and Attend* Acrylic and gold inks, collaged rubricated letter and foil on Khadi handmade paper

Page 18: *The Eternal Now* Sumi ink and coloured on Saunders HP paper

Page 19: *The Book of Wisdom* Sumi and gold inks, casein-based acrylics on canvas with gold leaf and foil

Page 20: *Psalm 8* 23-carat gold leaf over gesso, sumi ink, gouache and coloured pencil on calfskin vellum

Page 21: *Love Your Enemies* Gouache, hand-coloured stamp and coloured pencil on Saunders HP paper

Pages 24–5: *Let Your Light Shine* Gouache, black ink and gold foil on Conqueror

Page 26: *Let Not Your Heart Be Troubled* Sumi and gold inks, gouache and 23-carat gold leaf on Laid paper

Page 27: *Great Wisdom is Required of You* Sumi and copper inks, gouache and foil on Saunders HP paper

Page 28: *St Theresa's Prayer* Gold and acrylic inks with PVA, 23-carat gold leaf and foil on Magnani paper

Page 29: *Let Me Sing the Song of Love* Gouache, gold powder and 23-carat gold leaf on calfskin vellum

Page 32: *I Shape My Heart Like Theirs* Hand-coloured linocut collage with ink, coloured pencil and 23-carat gold leaf on Khadi handmade paper

Page 33: *St Francis' Prayer* Inks and gold leaf on Saunders HP paper

Page 34: *To Be Happy* Collaged papers, gold ink and gouache on Magnani paper

Page 35: *Be Like a Little Child* Hand-coloured linocuts, embossing and pencil on Twinrocker handmade paper

Page 36: *Stars and Blossoming Fruit Trees* Collage of monoprints, Japanese paper, pencil and palladium leaf

Page 40: *That Which is Within You* Hand-coloured linocut, coloured pencil and sumi ink on Magnani Laid paper

Page 41: *It Works* Acrylic inks, gold powder and graphite pencil on Arches HP paper

Page 45: *Let Yourself Be Silently Drawn* Automatic and ruling pens with acrylic inks on Saunders HP paper

Page 46: *Hear Blessings* Ruling pen with acrylic inks, coloured pencil and gilding with 23-carat gold leaf

Page 47: *To Find a Pearl* Gesso on canvas with powdered pigment, inks and gold, silver and variegated foil

Pages 48–9: *When Two Lovers Meet* Gold and bronze inks with watercolour pencil, 23-carat gold leaf and collage of wedding invitation (it was a wedding gift)

Page 50: *An Awake Heart* Hand-coloured linocut with pencils, gold ink and foil; lettering using white ink with ruling pen

Page 51: *Be Happy For This Moment* Linocut with sumi ink lettering

Page 54: *Enter Unhesitatingly Beloved* Acrylic inks with ruling pen and wooden stick, PVA, 23 carat gold leaf (sanded back), black ink and foil on Arches

Page 55: *I Searched But I Could Not Find Thee* Adhesive contact film, gold and bronze acrylic paint, palladium leaf and white ink on Arches HP paper

Page 56: *Love One Another* Gouache and 23-carat gold leaf on Saunders HP paper

Page 57: *Beauty is not in the Face* Gesso on canvas with powder pigments, pencil, ink, collage and palladium and gold leaf

Page 59: *There is No Way to Happiness* Limited edition letterpress print, hand finished with 23-carat gold leaf, Magnani handmade paper (printed by Electio Editions)

Page 62: *All That We Are* Gessoed canvas with powder pigment, black ink and collage

Page 63: *The Unsurpassed Ultimate Truth* Gouache, black ink, neocolours, gold ink and 23-carat gold leaf

Page 64: *Kissing the Earth With Your Feet* Limited edition giclee print, hand-finished with gold leaf (the original was a hand-coloured linocut written with gouache and gold ink and finished with 23-carat gold leaf)

Page 65: *Cultivate Contentment* Monoprint collage with sumi ink and gold leaf

Page 66: *Be Still Like a Mountain* Reduction linocut with pencil inscription

Pages 68–9: *The Four Treasures of Life* Walnut, indigo and gold inks on cold press paper

Page 71: *He Enjoys Happiness* Walnut, indigo and gold inks on cold press paper

Pages 72–3: *Bhagavad Gita XVI, 1–3* Limited edition letterpress print, hand-finished with 23-carat gold leaf, Twinrocker handmade paper (printed by Electio Editions)

Page 76: *Gayatri Mantra* Acrylic ink and paint, sumi ink and 23-carat gold and palladium leaf on Magnani paper

Page 77: *In This Body* Gouache, gold ink and watercolours on Arches HP

Page 80: *By His Shining All This Shines* Sumi and acrylic inks on Saunders HP

Page 81: *When You Are Inspired* Limited edition letterpress print hand-finished with 23-carat gold leaf (printed by Electio Editions)

Index

With gratitude

We would like to lovingly acknowledge the unending support of our parents, and the deep guidance and insights of the world's great philosophical traditions and teachers.

Special thanks to Deirdre's early calligraphic teachers and mentors — Dave Wood, the teachers at Roehampton Institute, and many lettering artists and friends across the world, too many to name. Thank you to the art and calligraphy-loving public without whose appreciation there would be no inspiration to be a calligraphic artist. Special thanks also to Mark Hassed who photographed most of the works for this book and to Jurgis Maleckis who photographed a few. Thank you to Rabbi Rami M. Shapiro for his gracious permission to use material from his modern reading of Pirke Avot. A special note of thanks to Hikmet Barutcugil from Turkey for his generous and beautiful gift of Ebru, hand marbled papers, which have been used as backgrounds in two works in this book. A deep word of gratitude also to our friends at Exisle Publishing who saw the potential of this project and so beautifully brought it to fruition.

Deirdre and Craig Hassed